THE CRITICAL VISION

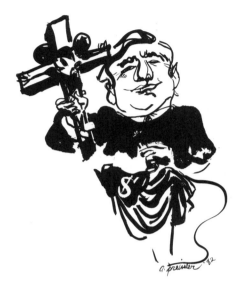

THE

CRIT

a history of

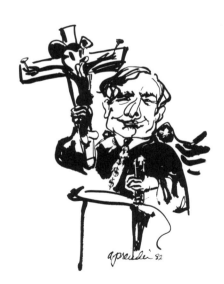

With editorial assistance and
contributions by Mark Resnick

PAUL VON BLUM

ICAL VISION

social and political art in the u.s.

a. preissler

SOUTH END PRESS

First printing
Cover, book design
 and production by Lydia Sargent
Printed in the USA

Library of Congress Number: 82-061156
ISBN: 0-89608-171-0 paper
ISBN: 0-89608-172-9 cloth

SOUTH END PRESS 302 COLUMBUS AVE BOSTON MA 02116

For Ruth and Elizabeth

CONTENTS

List of Illustrations

Acknowledgments

Preface

Introduction

LIST OF ILLUSTRATIONS

ACKNOWLEDGMENTS

Writing a book involves an extreme range of emotions, from intense exhilaration to severe depression. The opportunity to acknowledge the many people who have contributed to "The Critical Vision" brings me, once again, to the exhilaration end of that continuum. I only wish that I could write about their contributions in much greater depth.

Several academic colleagues have been unusually generous with encouragement, advice, and specific criticisms and suggestions. I am especially grateful to many individuals at UCLA who have helped me find the most comfortable and satisfying institutional setting I have had in many years. Chuck Ries, Andrea Rich, Bill Winslade, Jane Permaul, Paul Rosenthal and Jeff Cole have had much to do with that. I am also delighted to mention my personal colleagues at UCLA. All of them help to create an extremely pleasant work environment: Bill Winslade, Bernard Towers, Judy Ross, Joan McDowell, Barbara Sackoff, Mary DeWire, Caroline Blattner, Carol Prager, and Norman Cousins. I also want to mention the faculty of the Freshman/Sophomore Professional School Seminar Program and the staffs of the Division of Honors and Field Studies Development. They too have made my stay at UCLA a genuine pleasure.

Equally important, friends from academic life and elsewhere have encouraged me to complete this project even during the most troubling moments of doubt. They have seen me live with this book for much longer that I feel comfortable in admitting. Their help and personal support merit thanks far beyond what I can express here: Steve Rood, Bonita Zisla-Rood, Steve Ferrey, Claire Baker, Ben Kaplan, Judith Shafton-Kaplan, Bob Ehrlich, Fred Reif, Laura Reif, Hans van Marle, Antje de Wilde, Carol Berne, Ron Goldstein, Sally Goldstein, Jim Harmon, Edie Bragg Harmon, Mark Kann, Cathy Kann, Alan Schoenfeld, and Jane Schoenfeld. All of them have shown me the powerful value of having a reliable support network.

I want to express my immense gratitude to the people at South End Press. They have displayed inordinate patience in the face of my cavalier attitudes toward deadlines. They have given me an extraordinary opportunity to be a part of the most important alternative to orthodox publishing in the United States today. I also want to extend special thanks to

Lydia Sargent for her outstanding efforts in guiding this project through to publication.

My gratitude too is due those who assisted me in very specific ways. Ellen Clark and Martha Rutherford capably handled the permissions and reproductions problems in the early stages of the project. Their efforts made it easier to complete this arduous and frustrating process later. Barbara Sackoff typed the final manuscript from edited copy that looked remarkably like a Jackson Pollock painting. She knows that my appreciation goes far beyond this tedious chore. Cameron Jobe provided photographic expertise of the highest order. He too knows of my enormous regard for his work. I appreciate, finally, the many men and women in libraries, museums, and galleries who assisted me in myriad ways and the cooperative and gracious help of several artists who appear in this book.

In any project of this magnitude, a few persons contribute so profoundly that any formal acknowledgment can only be embarrassingly inadequate. Mark Resnick worked as the editor of "The Critical Vision" for several months. It was my great fortune to meet a person who could combine a brilliant verbal facility with an exceptional knowledge of art history and politics. These spectacular intellectual gifts enabled him to organize and transform the manuscript into a book—a very profound accomplishment. I want to add that his efforts were far more than editorial. He made major substantive contributions throughout the text. My debt to him is overwhelming.

I feel similarly about Karin Pally. In the latter stages of this project, she coordinated the entire process of permissions and reproductions. Her ability to function effectively in the face of Kafkaesque challenges was astounding. Her organizational talent was instrumental in solving problems that struck me as hopeless and bizarre. Her real contributions, however, go far beyond her administrative expertise. Her intellectual insights and her personal concern have left an indelible impression.

No one could possibly have been more important in this whole project than Ruth Von Blum. As in the past, she has been involved in every stage of this enterprise. Her intellectual influence has been magnificent in every respect. Beyond that, she has again endured my various forms of craziness throughout this project. She has provided love and companionship during a period of major strains and changes in our lives: political struggles, job changes, cross country moves, and the birth of a child. Our relationship has been the major source of emotional support for this book and the central feature of our lives.

PREFACE

Political and social artists have rarely been given the acclaim they deserve. They receive scant attention in most art history books, journals, and newspapers. "The Critical Vision" is part of my long-term objective of countering this pattern of scholarly and critical neglect. A few years ago, in "The Art of Social Conscience," I presented a survey of socially engaged art that ranged from the time of Brueghel to the present. The focus was largely European, with some material on U.S. and Mexican artists.

The present effort is an expansion of themes that appeared more peripherally in the earlier work. My desire is to show that artistic social criticism is a major form of cultural expression in the United States. Socially committed artists here have created an impressive body of work during the past two centuries. "The Critical Vision" is intended as a modest attempt to bring their work to public attention.

This book is also addressed to people on the left. Many radicals, political activists, and progressive intellectuals seem unaware of the myriad dimensions of left-wing culture. There is, I think, a certain ignorance about the artistic, musical, literary, and theatrical heritage that has contributed to the various movements for political change. I hope to erode this ignorance in some small way. I also hope to stimulate thought and discussion about the broader and more theoretical questions about the relationship between politics and culture.

I have tried to accomplish all my goals by presenting a survey of socially conscious art in the United States from the Revolution to the present. I have sought an appropriate diversity of artists who work in different media, who represent different styles, and who treat different social and political issues in their work. I have selected some well known artists and some lesser known artists for inclusion. Any survey, of course, is necessarily subjective and personal. I am all too aware of some serious omissions. I regret in particular that I have neglected such artists as Lynd Ward, Anton Refregier, Hugo Gellert, Adolf Dehn, Isobel Bishop, Arthur Szyk, Bernarda Bryson, Rico Lebrun, Irving Norman, W. Eugene Smith, Jacob Landau, Seymour Rosofsky, and Romare

Bearden. All of these people—and many more—are important representatives of the artistic tradition I seek to promote. I freely confess to having made a variety of arbitrary judgments in the final version of the text.

I write about socially conscious artists in part because I am sympathetic to their objectives. Most of the time I share their critique of political, cultural, social, and economic life in the United States. While I have sought to discuss their work as objectively as possible, the book itself reflects the same sense of partisan engagement that motivates the artists. I lay no claim whatever to that strain of scholarship or criticism purporting to be detached from the political and social struggles of human beings.

April, 1982
Venice, California

INTRODUCTION

A neglected tradition of artistic expression exists in the United States. It combines technical excellence with a critical vision of society. From before the Revolutionary War to the present, artists working in this tradition have created a powerful monument to political dissent and moral conscience. These men and women, sharing a vision of the harsh realities of life, have used their talents to illuminate the defects of social and political existence and to point to the possiblities for change.

Usually ignored, patronized, or disparaged by critics in academia and in the popular media, these socially engaged artists have generally worked without the status and recognition accorded to their more politically conventional contemporaries. Their works of social commentary have rarely been seen or presented as a tradition. This book seeks to identify and to legitimize this critical vision in American art history. What follows is a survey of some of the major highlights of the critical visual tradition in the United States during the past two centuries. The artists who have produced these works encompass a wide range of intention and political and social ideology. They have employed almost all artistic media in their critique and expose of injustice and brutality in the U.S. and elsewhere. Their paintings, graphics, murals, sculpture, and photography cumulatively stand as a dramatic indictment of a social order that frequently neglects to address the needs of its diverse inhabitants. This book, above all, presents a tradition of political engagement that complements the tradition of dissent in literature, journalism, speech, film, and scholarship.

The works that form this tradition treat exclusively the expression of social themes and ideas. This emphasis on content is a radical departure from the formalist orientation of most modern art and of orthodox criticism and scholarship. Especially in recent decades, artists and critics alike have been infatuated with visual abstraction and with the formal hallmarks of artistic creation. As a result, concentration on artistic content has been viewed with considerable suspicion. Thematic concerns, particularly those focusing on a critical view of politics and society, have often been regarded as quaint, out-of-date, or merely topical. A self-serving ideology of "modern" art has dominated U.S. cultural life in the 20th century. With remarkable success, it has defined the visual communication of political opposition as beyond the pale of respectability in the tightly managed art world.

Artists seeking to communicate thoughts and feelings about society can scarcely avoid an emphasis on content. It is time to oppose the present cultural orthodoxy by presenting a more sympathetic treatment and appraisal of their efforts. Accordingly, it is necessary to underscore the value of both

creating and examining artistic content, and it is equally urgent to note the dangers inherent in emphasizing solely formal considerations. This latter tendency has served to separate art from the wider context of life. It has encouraged artists and critics to avoid commentary on controversial issues of social policy. It provides an academic rationalization for indifference to political affairs, a posture that historically has justified existing social, economic, and political institutions and priorities. Formalism is thus a manifestation of political as well as cultural conservatism, whether intended as such or not.

The Critical Vision, intended as a modest antidote to this present disdain for artistic content, considers form and technique mainly insofar as they forward social content; formal analysis is subordinated.

The works that follow may properly be called the art of social conscience. Because of the enormous diversity of artistic style and content within this movement, it is useful to identify and to briefly develop some of the theoretical foundations that underlie the creation and expression of such work. Socially conscious art is characterized by a complex commitment to realism, social protest, and accessibility. Eschewing the bourgeois notion of "art for art's sake," artists of social conscience produce visual editorials about social and political struggles that can be viewed (hence the frequent employment of print media) and understood by the multitudes. In short, these artists manipulate materials and technique for *life's* sake.

Tastemakers in Western culture have often sought to divorce the arts from life. Like music, literature, and drama, the visual arts have regularly been presented in rarified fashion. "High" art, in all forms, encourages people to passively await entertainment in theaters, concert halls, galleries, and museums. This mentality also generates smugness and political apathy, thus affirming existing political arrangements. Most disturbing, such art is generally available only to the affluent, for whom "culture" is often little more than another commodity sold via the consumption orientation of modern capitalism.

The art of social conscience deliberately negates this tendency. Its visual realism is non-escapist, focusing on "real life" events and issues in order to appeal to a more popular audience. And its establishment of accessibility as a major priority has profound implications for both style and content. Socially engaged artists necessarily render recognizable, identifiable forms. Artistic abstraction is rejected as inappropriate. In order to stimulate the viewer's active response to work that deals with social and political issues and events, the visual imagery must appeal to the viewer's background

and consciousness. It is necessary, however, to qualify the use of the term "realism" in this context. Realism all too often evokes images of slavish copying or "photographic" rendering. Good socially conscious art combines trenchant commentary with imaginative form. Of course, the finest American representatives of this tradition have used metaphor and abstract forms in pursuit of their broader critical objectives.

In fact, it has largely been the subject matter of socially conscious art that places it within the realistic tradition. The "reality" depicted has often been tough and unpleasant, demanding a critical palette.

Virtually every form of injustice in U.S. history has served to stimulate socially conscious artists. War, slavery, class exploitation, racism, sexism, imperialist adventures in foreign affairs, internal assaults on civil liberties—all these and more have caused artists to respond with passion and indignation. Their goal has been to raise public consciousness and to stimulate resistance to repression—not to provide sophisticated intellectual analysis.

Many socially conscious artists were trained in realistic reportage, especially in the 19th and 20th centuries. Many had been journalists before turning fully to the visual arts. Others managed to combine commitments to both art and journalism throughout their careers. This background sharpened their eyes to real life and enhanced their movement from verbal to visual forms detailing the events of the day.

Equally important, artists with this journalistic background were accustomed to producing for a popular audience. Their reportage appeared in newspapers and magazines read by unprecedented numbers of people. And employment as a reporter or illustrator was especially important in the era before the advent of photography. Indeed, the emergence in the 20th century of socially engaged photojournalism owed much to this tradition.

As "visual editorialists," socially conscious artists are often intentionally hyperbolic. They seek to evoke powerful emotional responses in the viewer. Their desire to foster partisan reaction often provides a dramatic prelude to both analysis and action. They endeavor, sometimes successfully, to provide a visual catalyst for social awareness and transformation.

The American art of social conscience does not stand in historical isolation. For many centuries, a minority of European artists have similarly employed their creative skills in identifying and attacking a wide range of political and social problems. At least as early as Brueghel, both major and minor figures in Western art history have consistently produced works outside the "high art" tradition of the Academy. A brief review of this tradition's highlights will facilitate a

systematic examination of the American contribution to it.*

The work of Brueghel in the mid-16th century, for example, has had a powerful influence on modern socially conscious artists. His depictions of greed, political persecutions, and terror are even now dramatic reminders of exploitative social arrangements. William Hogarth's 18th century artworks in England exposed such problems as poverty, wretched prison conditions, and upper and middle class hypocrisy. His pictorial "stories" called public attention to the tensions of modern industrial life and created a context for social reform. Equally influential was the Spanish master Francisco Goya, whose works combined brilliant technique with trenchant protest. His graphics on the horrors of war, for example, are among the most powerful in art history. Throughout most of the 1800s in France, Honore Daumier's lithographs opposed monarchy and capitalism and advanced the cause of a democratic republic. His work established a standard of excellence for visual satire and inspired generations of European and American artists. Finally, since the 17th century, there have consistently been so-called genre painters, for whom the entirety of society is worthy of observation and depiction. For them all life is fascinating, including "low life." Art no longer need be beautiful; real life has its own beauty and is compelling in itself. This attitude has been enormously important to the tradition of socially conscious art, for the portrayal of ordinary life and people has done much to erode elitist artistic notions blocking the development of a popular social art.

Any treatment of art emphasizing social protest and criticism raises interesting and difficult theoretical questions about the relationship between art and politics. It is valuable to identify such questions though they are incapable of definitive answers. A fundamental issue is whether art and politics can genuinely mix and, if so, to what extent.

For centuries, artists, critics, and others have debated whether creative works can be both artistically fine and politically instructive. Throughout this book, there are indications of how particular U.S. artists try to resolve this problem.** Different artists, of course, seek such resolution in diverse and often highly personal ways. It is significant, however, that for many the answer is to produce art that is overtly didactic or patently propagandistic; for these artists, directness best synthesizes creative energy and political commitment.

*For histories of this tradition, see Shikes, *The Indignant Eye* and Von Blum, *The Art of Social Conscience.*

**For a sustained treatment of these issues, see Fitzgerald, *Art and Politics.*

A dominant view in the art world, however, is that art and politics simply do not mix—or at least that they do not mix well. To be sure, this dogma of separation conveniently protects established interests in both art and politics. The ritual incantation by established critics that art must stand above the strife of political conflict must be examined for its political motivation. Yet it should be noted that the art/politics mix is at times awkward and strained. Some political and "protest" art has been inferior in artistic quality and in political acuity. At times, passionate involvement in the affairs of the day has caused artists to compromise their craft and to oversimplify social and political issues.

Other serious problems in mixing art and politics derive from the existence of a highly controlled and institutionalized national art market. The blunt reality is that the market, manipulated by powerful economic interests and supported by established art historians and critics, determines what art will sell. And the market significantly influences public appreciation and acceptance of artistic form and content. It is natural that art that criticizes capitalism and its social institutions suffers in popularity and marketability.

The protest or radical artist often must choose between an artistic career or a political career or merely succumb to the demands of the marketplace. For example, Robert Minor, a radical illustrator in the early 20th century, finally abandoned his artistic enterprise and spent the rest of his life as an organizer for the Communist Party. John Sloan moved in the opposite direction. Also a radical illustrator, he experienced a conflict between political activism and artistic engagement. Eventually, he devoted his attention to art, eschewing direct involvement in the socialism to which he subscribed. Many other artists, finally, have produced marketable works while continuing a commitment to social criticism in visual form.

While economic factors have greatly affected socially conscious artists, it would be erroneous to conclude that all political artists exist on the fringe of society. Many have managed to continue a dedication to political art and political action while fully integrated, if not always affluently so, into the social mainstream.

The art/politics connection also raises another fundamental issue: To what end is such art produced? Socially conscious artists vary widely in temperament and ideology. Some have been reformist, others revolutionary. Their works sometimes reflect these postures and sometimes do not.

All socially conscious artists share a critical outlook on major aspects of society. Like all critics, they hope for some kind of social change. All seek to express their discontent in visual form and in whatever artistic medium they find most congenial and effective. Beyond these general similarities lie

some major differences in attitude and motivation. Examples from the broad tradition of socially conscious art provide a glimpse into the enormous diversity of viewpoints that have been represented. Mexican muralist David Alfaro Siqueiros, for example, combined his art with a lifelong commitment to Marxism-Leninism. Some of his works reflect this revolutionary zeal. Some are more broadly humanistic, revealing compassion for suffering largely independent of sectarian concerns. Kathe Kollwitz, active in the political left in Weimar Germany, ennunciated a pacifism acutely sensitive to the victims of war and, further, to economic catastrophe. Georges Rouault rooted his own anti-war attitude and empathy for the poor in a deeply held belief in Christianity. He therefore frequently combined social protest and commentary with religious imagery. George Grosz and Honore Daumier were more generally satirical than they were representatives of identifiable left positions or factions, and their works derived as much from personal temperament as from specific political positions.

American representatives of the social tradition are equally diverse. The Ashcan artists of the early 20th century, for example, seemed to revel in as much as they criticized the hideous urban realities they portrayed; their work was at least as descriptive as it was critical. Politically, they were, at most, liberal reformers, often with little to say about root causes of poverty and alienation. Generally, their desire was to transform the world of art rather than political affairs. Yet their efforts still had significant social consequences. For, even if their humanitarianism was only incidental to description and even if their art was only mildly critical or partisan, the fact is that they depicted what most other artists shunned. Their very selection of social subject matter prompted viewers to consider a reality they might otherwise have ignored. Such art at the least moves people to confront larger issues and thus increases the probability of responsive social action.

Descriptive and reformist strains of the art of social conscience differ from revolutionary strains. The latter advocate radical social transformation and actively exhort the audience to revolutionary action. There is, however, much difficulty in defining precisely what constitutes revolutionary art; very little of the vast body of socially conscious art is unambiguously revolutionary. Some poster art, however, combines powerful visual imagery with specific revolutionary rhetoric. And some recent work of radical black artists also appears to urge revolutionary change rather than social reform.

Socially critical artistic creation has rarely resulted in direct and immediate political change. Most artists who have

pursued a political vision in their work have understood that art is only a small part of a more comprehensive process of critical consciousness and political action. They have realized that artistic criticism is like criticism in any form, a stimulus to public awareness having special appeal to certain segments of the population.

In a deeper sense, all socially conscious art has meaning for society. Regardless of the specific political posture of the artists or the specific political consequences of their work, their efforts commemorate, educate, and liberate. The very act of opposing oppression and injustice is a profoundly ethical act. The dignity inherent in moral opposition to racism, sexism, imperialism, and class oppression is important in itself. As Albert Camus has written, rebellion stands as a measure of human worth in the face of degrading social conditions.

The fusion of art and social criticism has enormous significance for artists themselves. It is personally liberating and in ways that often reinforce enduring political commitment. Charles White, whose entire life as an artist was spent chronicling the struggles of blacks in the United States, eloquently expressed his concerns:

> I am interested in the social, even the propagandistic angle of painting...that will say what I have to say. Paint is the only weapon I have with which to fight what I resent. If I could write, I would write about it. If I could talk, I would talk about it. Since I paint, I paint about it.*

Another contemporary artist, Hans Haacke, indicates the immense value in socially critical art for reasons far transcending its limited political consequences:

> I would be a megalomaniac if I thought that was going to radically change things...I don't think it is in vain, but I also don't think one should have overblown expectations. There are many people in practically every profession trying to look at things from an alternative point of view...Seen in this larger context this art is not quite insignificant. It is like a piece of mosaic, potentially giving the whole an ideologically somewhat different coloration. But even without this, I find it personally gratifying to spell out the things that rub... Alienation needs to be articulated rather than suppressed.*

*Quoted in Elsa Honig Fine, *The Afro-American Artist* (New York: Holt, Rinehart, and Winston, 1973), p. 170.
**View interview by Robin White, at Crown Point Press, Oakland, California, 1978, p. 8.

Like their counterparts in factories, offices, the professions, community political groups, and elsewhere, socially conscious artists have tried to promote a vision of a society that can be more decent, healthy, satisfying, and free from manipulation and exploitation. The importance of their work lies above all in its contribution to the realization that only by political awareness and mobilization can the human condition be improved. The works that follow are powerful testimonials to that goal.

Art motivated by social conscience did not fully flower in the United States until the 20th century. With the exception of Thomas Nast, little in the early U.S. tradition compares favorably with the work of such European masters as Hogarth, Goya, and Daumier. Most 18th and 19th century social commentary art consisted of highly topical cartoons. Opinionated comments on narrow political and social current events, they achieved little recognition beyond their time. American cartoonists before Nast generally were imitators of such English satirists as Rowlandson and Gillray; their works now inspire only a mild, historical interest.

One of the earliest examples of protest art in the U.S. is found in the work of Paul Revere. Known generally as a silversmith, he was a vigorous supporter of the American Revolution. He also created one of the most important works of early American protest art, a depiction of the March 1770 Boston Massacre.

For two years prior to the Massacre, minor clashes between Boston residents and British soldiers had been commonplace. On March 5, one of these clashes became a small riot. Aggressive and belligerent bands of colonists and soldiers roamed the streets of Boston. Soon, a crowd gathered at the Custom House, exacerbating matters. Eventually the British soldiers reacted by firing into the crowd, killing three persons immediately while two others died shortly thereafter.

Revere responded with the print *The Boston Massacre* (figure 1-1). Although there is some evidence that he copied from a print by Henry Pelham, this work's fervor nonetheless

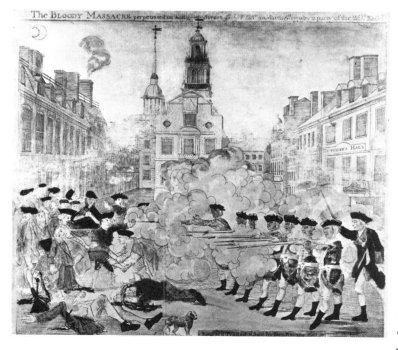

Fig. 1-1. Paul Revere, "Boston Massacre," from Collections of the Library of Congress.

captures the spirit of the first real battle in the struggle for independence. Widely distributed in the colonies, the print had substantial political effect. The work depicts British soldiers firing point blank at civilians. Revere's depiction of the mortally wounded victims is designed to evoke the viewer's outraged response. While artistically unsophisticated, the print has retained its importance as one of the earliest of its kind.

Edward Hicks (1780-1849)

Edward Hicks (1780-1849), a "primitivist" who lacked formal training, exemplifies the religious strain of some early U.S. socially conscious art. Hicks employed large, awkward figures in works more attuned to substance than form.

As a youth, Hicks was first apprenticed to a coach maker and then became a sign painter. He was a rowdy given to drinking. Eventually, overcome with remorse, Hicks sought salvation in religion. He joined the Society of Friends who were then well known in his home state of Pennsylvania. He immersed himself in the religious and social Quaker doctrine, and embarked on a travelling ministry. He turned from sign painting to easel painting in order to express his religious convictions and especially his pacifism.

Hicks, embarking upon a theme that would dominate his career, found inspiration in the Bible:

> The wolf also shall dwell with the lamb, and the leopard shall lie down with the kid; and the calf and the young lion and the fatling together; and a little child shall lead them.
> And the cow and the bear shall feed; their young ones shall lie down together; and the lion shall eat straw like the ox.
> And the sucking child shall play on the hole of the asp, and the weaned child shall put his hand on the cockatrice's den.
> They shall not hurt nor destroy in all my holy mountain; for the earth shall be full of the knowledge of the Lord, as the waters cover the sea.
>
> Isaiah XI: 6-9

Hicks produced more than fifty variations of this theme. In a representative work, (figure 1-2), the leopard, ox, and lion dominate the composition. Visual representations of scripture, these "Peaceable Kingdoms" reflect the artist's longing for a peaceful society.

Hicks greatly admired the Quaker leader William Penn, who appears prominently in his paintings. When the colonists arrived in the New World, many of them viewed the "Indians" as a threat to civilization and wanted to eliminate their population. Penn, however, treated them as a separate nation and as a culture worthy of respect and cooperation. In

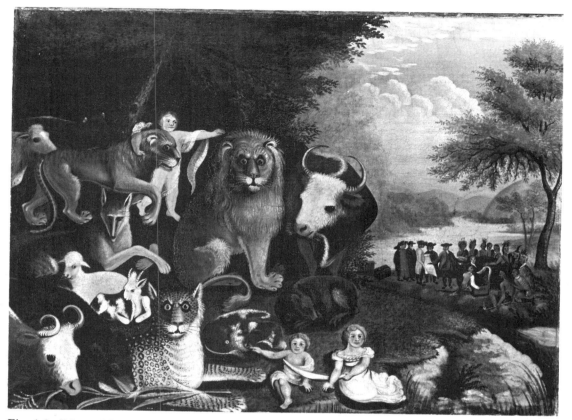

Fig. 1-2. Edward Hicks, "The Peaceable Kingdom," The Brooklyn Museum of Art, Dick Ramsay Fund.

a 1830 painting entitled "Penn's Treaty With the Indians," Hicks hailed Penn's openness and his willingness to conciliate. Although copied from Benjamin West's famous depiction of the same subject, the painting is distinctive; its naive style contrasts markedly with the detached formalism of much European-influenced American art.

Hicks' painting depicts Penn and his colleagues in harmony with the Indians. This conception of Native Americans as rational humans desirous of peace was all too unusual among Hicks' contemporaries. The humanism of Hicks' works elevates them to a level of far greater significance than that occupied by the period's political cartoons.

Thomas Nast (1840-1902) was the greatest 19th century exponent of the artistic tradition that men such as Hicks had begun. Nast was a cartoonist and illustrator as a youth, and his work appeared regularly in *Harper's Weekly* for 25 years. Nast was concerned with highly topical issues. Yet, like his French contemporary, Daumier, Nast's work has endured because of its universal character and because of the consummate skill with which it was rendered. His subjects

*Thomas Nast
(1840-1902)
Cartoonist & illustrator*

included the Civil War: the presidential administrations of Johnson, Grant, Hayes, and Garfield; problems of church and state; minority groups and civil rights; and labor and capital. Nast's most important and sustained work, however, attacked political corruption, particularly that found in New York City's Tweed Ring of the 1860s and 1870s.

Throughout his career, Nast was motivated by a radical republican ideology that combined with his idealistic Protestant morality. Many of his values were those of the Emancipation, especially as it was embodied by the 14th and 15th Amendments to the United States Constitution. Nast viewed social and political life with a consistent, albeit somewhat simplistic, moralism.

Nast's career as a political cartoonist dated from the Civil War. While his work was invariably pro-Union, some cartoons concentrated upon the horror of war itself. An outstanding example is "The Result of War-Virginia in 1863" (figure 1-3), a powerful depiction of human destruction in somber black, white, and gray tones. In countering the usual romantic glorifications of war, Nast follows in the tradition of Goya. Rouault. Kollwitz. and Dix.

Fig. 1-3. Thomas Nast, "The Result of War—Virginia in 1863."

After the Civil War, Nast's work castigated President Andrew Johnson for his alleged betrayal of the principles of Abraham Lincoln; also criticized were those Southerners who continued to oppose civil rights for the recently freed slaves. Nast's most important work, however, occurred a few years after the turmoil of the Civil War and Reconstruction had subsided.

From 1866 to 1871, an extremely corrupt band of New York politicians allied with Tammany Hall to control New York City. The Tammany phenomenon was immensely complex. It typified the machine, backroom urban politics which has recurred throughout U.S. history. Yet Tammany also provided a support mechanism for thousands of impoverished Irish Catholic immigrants to the United States, immigrants who might otherwise have been utterly alienated by the new country's hostile economic and cultural forces.

Ostensibly a patriotic and social club, Tammany dominated the Democratic Party in the latter 19th century. Staffed largely by Irish Catholics, in the late 1860s Tammany Hall established a pattern of political payoffs, graft, thievery and personal avarice. The machine was headed by William Marcy Tweed, the "Boss," and its survival meant infinitely more to him than did ideology or social policy.

Nast was horrified by the Tweed Ring's pervasive corruption and he and the editors of *Harper's Weekly* set out to expose the group. Although Nast was probably equally interested in helping his radical republican friends eliminate the Irish from city government, his distaste for corruption was nonetheless sincere.

At the height of its power, Tammany had 60,000 patronage positions and had gained control of the New York bureaucracy. The Tweed Ring awarded contracts only to those who would kick back substantial sums of money and, further, it controlled the courts and much of the State legislature. In a remarkably short time, the group had run up a public debt of $50 million.

Nast's engravings exposed the hypocrisy of Boss Tweed, who claimed to be the champion of the New York City poor. In "The Tammany Lords and Their Constituents," which appeared in *Harper's Weekly* in September 1871 (figure 1-4), Boss Tweed and his cronies are shown cavorting over champagne at the public's expense. In striking contrast are the poor workingman and his family in the work's lower panel. The landlord at the front door brings the usual bad news: higher taxes, higher assessments, and higher rent. Humiliated and distraught, the father sits in the corner of his miserable tenement dwelling, while his children cower. The bloated Tweed gazes down from above.

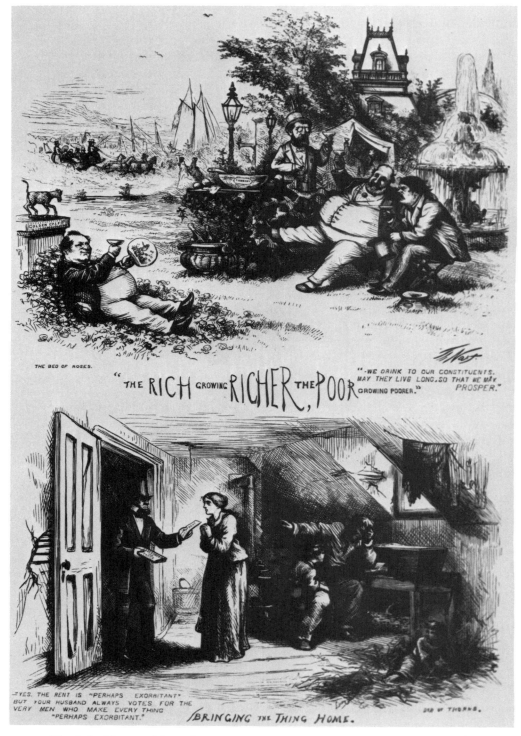

Fig. 1-4. Thomas Nast, "The Tammany Lords and Their Constituents."

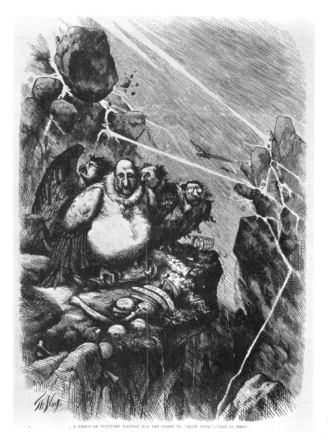

Fig. 1-5. Thomas Nast, "A Group of Vultures Waiting for the Storm to 'Blow Over-Let Us Prey,'" from Collection of Library of Congress.

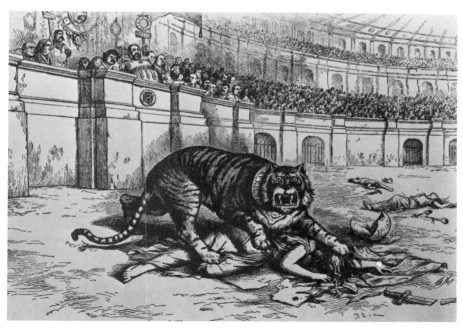

Fig. 1-6. Thomas Nast, "The Tammany Tiger Loose, What Are you Going to Do About It?"

In the same month, Nast created the landmark work "A Group of Vultures Waiting for the Storm to Blow Over" (figure 1-5). Boss Tweed and his closest associates are portrayed as rapacious birds, trying desperately to weather the storm of social criticism that has been directed against them by Nast and others. The corpse of New York City lies beneath them, along with the skeletal remains of the other victims of Tammany corruption: taxpayers, law and justice, and suffrage. An example of Nast's masterful use of detail is the muzzle located at the Tammany conspirators' right. Labelled "For the Press," it bespeaks Tweed's methods of countering opposition to his rule. The engraving's most dramatic feature, however, is the boulder ready to annihilate Tweed and his henchmen, a portent which would soon be fulfilled.

Nast's attack began to achieve success. Frightened by possible loss of power, Tweed sought both to bribe and threaten Nast. Nast declared that he would continue his attack until Tweed was behind prison bars.

Nast published several scathing works shortly before the November 1871 New York municipal elections. The most effective was an admonishing cartoon entitled "The Tammany Tiger Loose-What Are You Going To Do About It?" (figure 1-6). Here, Nast's representation of Tammany power, the tiger, savagely claws the symbol of the Republic while Tweed, sitting Ceasar-like, savors the spoils of his corrupt regime.

Many of Tweed's associates were defeated in the 1871 election. Unlike most of his colleagues, Nast thus saw his work effect real change. Soon, many Ring members were arrested, tried, and convicted of serious criminal offenses; others fled into exile. Finally, Boss Tweed himself was sentenced in 1873 to 12 years in prison, only to escape confinement and flee to Spain. Eventually, Tweed was apprehended by authorities who recognized him with the help of another famous Nast cartoon; he was returned to the U.S. where he died in prison in 1878.

Nast's successful series on political corruption qualified him as a prominent national figure. A progressive, Nast had persistently attacked racism, advancing the cause of Blacks, Native Americans, and Chinese. Typical is the 1879 cartoon "Every Dog (No Distinction of Color) Has His Day" (figure 1-7), a work which called attention to U.S. racism and xenophobia in its depiction of minorities then under assault. Particularly interesting is Nast's bitter condemnation of West Coast discrimination against Asians. The artist executed numerous related cartoons attacking the violence of the Ku Klux Klan and urging the passage and implementation of civil rights legislation. Ironically, however, Nast's own Republi-

Fig. 1-7. Thomas Nast, "Every Dog (No Distinction of Color) Has His Day."

can Party would ultimately acquiesce in U.S. racial discrimination.

Nast was also heavily involved in electoral politics, and his cartoons figured significantly in each presidential election between 1864 and 1884. His uncritical partisanship, however, diminished the value of his insights into political life. While his attacks upon President Andrew Johnson were often sound, his support of Ulysses S. Grant generally ignored the ineptitude of Grant's presidency. And though his stand on the separation of church and state was undeniably progressive, the Protestant Nash, in keeping with the thoroughly Anglo-Saxon character of radical republicanism, exacerbated prejudice against Catholics.

Nast's later works concentrated on topics of social and economic policy and on public morality. Although his cartoons dealt with the increasingly powerful militant labor movement, Nast demonstrated no real understanding of the oppressive conditions that generated such agitation. He summarily condemned labor unions as "communist" and "internationalist" and his sympathies for stability and law and order allowed for no real contemplation of the harsh realities of industrial capitalism. Near the end of his life, Nast left *Harper's Weekly,* turned to other artistic media, and finally accepted a minor diplomatic post in Ecuador, where he died in 1902.

On balance, Nast must be ranked as an important figure in artistic political criticism in general and as a major early representative of the American tradition. Despite his many shortcomings, his considerable integrity caused him consistently to focus public attention upon many of the serious social

and political problems of his day. An "honorable muckraker," Nast inspired scores of future artists to employ their talents on behalf of social reform.

Sympathetic portrayals of the struggles of labor, though not favored by Nast, were hardly unheard of in the visual arts. Throughout the 1870s and 1880s American workers struck for higher wages, shorter hours, and more humane working conditions. In 1886, the infamous Haymarket rally ended in the deaths of several policemen and demonstrators; and eventually five anarchist labor leaders were summarily sentenced to hang.

Robert Koehler

Also in 1886, Robert Koehler created "The Strike" (figure 1-8), depicting a strike in Pittsburgh of a decade earlier. This painting is the first major U.S. example treating the theme. The work is intentionally class conscious in its support of a group of militant workers in their confrontation with an industrialist. The worker stooping to pick up a rock underscores Koehler's vigorous, unambiguous support of labor.

Few other artists responded as partisanly to the era's industrial conflicts. Toward the end of the century, social and political life had become increasingly complex and troubled. The period had witnessed growing industrialization and the concentration of immense power in the hands of large corpo-

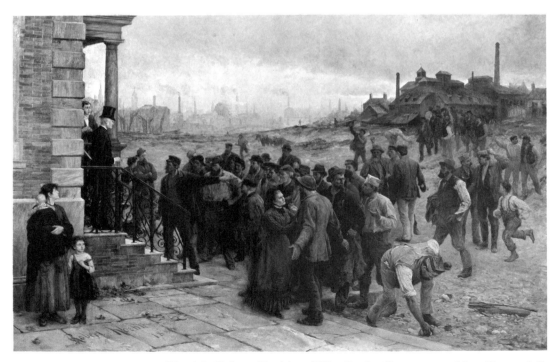

Fig. 1-8. Robert Koehler, "The Strike," courtesy of Lee Baxandall, photo by Geoffrey Clements.

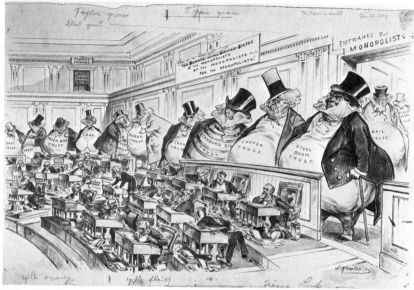

Fig. 1-9. Joseph Keppler, "Bosses of the Senate," courtesy of the New York Public Library, Aston, Lenox, and Tilden Foundation.

rations along with the mobilization of organized labor. Thousands of strikes had occurred, including some of the most violent and famous labor confrontations in U.S. history. The Pullman strike of 1893 was remarkable both for the leadership of Eugene Debs and for the intervention of strikebreaking federal troops. In retrospect, however, most of the works dealing with such social turmoil must be viewed as ephemeral.

More durable themes emerged in the productions of a *Harper's Weekly* competitor, the magazine *Puck. Puck,* founded by the important American cartoonist, Joseph Keppler, was a major source of cartoons commenting upon public issues of the times.

Born in Austria, Keppler was a Democrat in national politics. However, like Nast, he attacked Tammany Hall vigorously; and he was equally unsympathetic and naive in his treatment of organized labor. Keppler assaulted the powerful trusts and monopolies, born of ruthless competitive capitalism, which dominated most of the basic industries. Keppler's most famous work on the subject was the 1889 lithograph "The Bosses of The Senate" (figure 1-9), an effective expose of the influence of the major trusts on Congress. By the time this work had been executed, the Senate had become a club for millionaires. Presiding was a Wall Street banker, while other powerful Senators came from the ranks of dominant interests in oil, coal, railroads, lumber insurance, and silver. Keppler's lithograph asserts that the Senate was merely a formalized sham through which the interests of the powerful economic and social classes in the

*Joseph Keppler
Cartoonist*

U.S. were validated. The bloated leaders of the Senate are identified by the trusts they represent, while other Senators are dwarfed in comparison. The unsubtle "Bosses of The Senate" may all too fairly portray a distressing historical reality.

Besides the cartoon, another medium was becoming prominent in the realm of 19th century social art. In the 1860s, an impressive body of photographs documenting the Civil War had been produced by Matthew Brady and Timothy O'Sullivan. Masterpieces of social reportage, these views of carnage stand as landmark examples of wartime photography.

Jacob Riis (1849-1914) Photographer

In the late 19th century, Jacob Riis (1849-1914) emerged as a pioneering representative of photographic social commentary. Born in Denmark and trained as a carpenter, Riis had come to the United States in pursuit of greater economic opportunity. Soon, he had joined the staff of a Long Island weekly newspaper, and had begun to establish a career as a journalist. By 1877 he had landed a position with the New York *Tribune,* where he stayed for eleven years before moving to the *Evening Sun.*

Riis' work as a reporter brought him into contact with the sordid realities of New York City. He observed slum life and its consequences firsthand. Profoundly affected, Riis resolved to crusade against child labor and urban poverty.

At first, Riis employed his journalistic talents in calling public attention to the tragic conditions retarding thousands of immigrants' development and their enjoyment of life. Later, his photographs in books that he also wrote, such as *How the Other Half Lives, The Children of the Poor,* and *The Battle With the Slum,* produced classic examples of American social reportage.

Riis' use of the photograph made his campaign more effective: invading the slums with his camera, he emerged with visual proof that could not be ignored. His photographs were extraordinary historical documents, evocative, and of high aesthetic caliber.

Typical is "Five Cents a Spot" (figure 1-10), which depicts tenement conditions. In this crowded and filthy basement, twelve men and women spend the night, each paying five cents for the privilege. The photograph condemns such degradation and evidences the need for social reconstruction.

Among the finest of Riis' photographs are his portrayals of the child victims of widespread poverty. "Street Arab" (figure 1-11), taken near the end of the 19th century in New York City, shows three young children huddled in front of a tenement. Forced to fend for themselves in the slums, their chances for fruitful lives are staggeringly small.

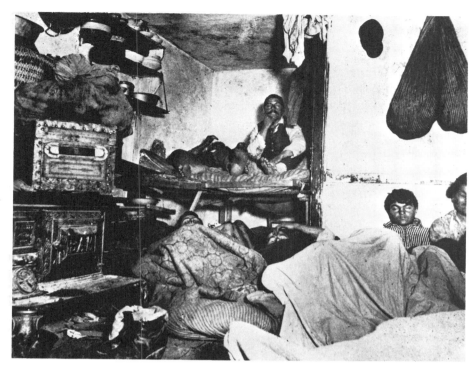

Fig. 1-10. Jacob Riis, "5¢ a Spot," courtesy of the Jacob A. Riis Collection, The Museum of the City of New York.

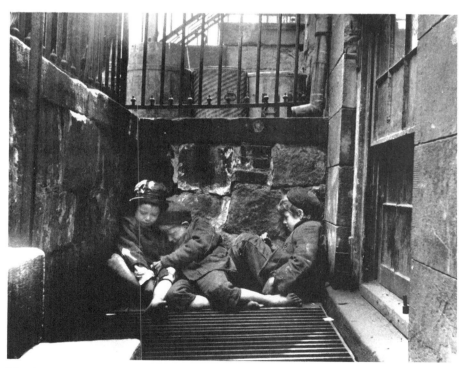

Fig. 1-11. Jacob Riis, "Street Arab," courtesy of the Jacob A. Riis Collection, the Museum of the City of New York.

The value of Riis' work lay in its emotional impact and in its educative and documentary functions. Today, Riis' photographs serve as powerful historical reminders of the dreadful conditions that faced earlier generations. The quality and moral vision of these works established Riis as one of the finest photojournalists in United States history.

Although each of the works and media that have been discussed in this chapter contributed significantly to an American art of social conscience, it was not until the early 20th century that a more comprehensible and durable tradition of such art would emerge.

Most of the social and political art of the 19th century had lacked maturity in both style and content. Formally, most of these works utilized a mode lacking the originality and imagination that would often characterize 20th century social paintings, graphics, murals, posters, and cartoons. And, as to content, most 19th century artists seem to have lacked the political sophistication of the finest radical artists of the next century.

The turn of the century in the U.S. heralded a commitment to realism in the arts. Writers such as Frank Norris, Theodore Dreiser, Stephen Crane, and Jack London found counterparts in the "Ashcan" school of painting. One strain of this school exerted an enormous impact on the development of American socially conscious art.

Although the major exhibition of Ashcan painting occurred in New York in 1908, the origins of this movement lie in the last decade of the 19th century. In Philadelphia at that time, a group of young artists were drawn to the energetic painter Robert Henri, who taught at the Pennsylvania Academy of Fine Arts. Henri became the leader and primary theorist of a group later to be known as "The Eight"—Henri, John Sloan, William Glackens, George Luks, Everett Shinn, Ernest Lawson, Maurice Pendergast, and Arthur B. Davies.

Most of these artists were experienced journalists whose training greatly influenced their art. They were close observers of urban life, and began a determined reaction against the prevailing view that art should be "for art's sake." They believed passionately that art should reflect both human experience and the artist's personal response to that experience.

Influenced fundamentally by such important European artists as Hogarth, Goya, and Daumier, the humanitarian Henri was a forceful advocate of justice. Liberal and idealistic reformers, he and his colleagues were alive to social change, political ideas, and new conceptions of the role of art. They held as axiomatic that art was never to be separated from life.

Henri and his followers were not reluctant to paint subjects traditionally considered inappropriate by academic artists. In a revolt against gentility, they sought to elevate truth over beauty. Thus these men portrayed "unpretty" subjects eschewed by members of the art establishment: boxing matches, beer drinking, urban tenements, garbage pails, indeed, much of human existence in the grimy, exciting cities of the Eastern seaboard. Their work, for its calculated inelegance, was accordingly labeled "Ashcan."

The Ashcan painters' dedication to realism allied the visual arts in the struggle of U.S. social criticism. These artists, especially John Sloan and George Bellows, shared a sympathy for the poor and the oppressed. Sloan and Bellows, both students of Henri, illustrated as well for the radical magazine *The Masses*. Although the magazine's focus was more revolutionary than that of the largely descriptive, reformist Ashcan school, artists such as Sloan and Bellows were attracted to both as a forum for radical social commentary. An overview of the two men's work in both contexts provides a sound introduction to socially conscious art of the early 20th century.

CHAPTER 2
EARLY 20TH CENTURY SOCIAL & POLITICAL ART

Ashcan School

*John Sloan
(1871-1951)
Painter & graphic artist*

Sloan (1871-1951) was trained at the Pennsylvania Academy of Fine Arts and worked as an illustrator for various newspapers and magazines. In 1892, he met Henri. Working closely with him, Sloan became the most political member of the original group of Ashcan artists. He was personally active in liberal crusades and in socialist electoral politics; indeed, for many years he devoted more energy to Party matters than to his art. Both a painter and graphic artist, he was a more effective social commentator in his etchings and drawings.

Sloan was not a political militant. Rather, he was profoundly sympathetic to the underdogs in U.S. society. Fascinated by "low life," he tended to sentimentalize working class existence. Yet his personal socialist commitment was predicated on the kind of sincere and generalized humanism found, for example, in some of the etchings of Rembrandt.

Heavily influenced by Daumier, Sloan often used his art to call attention to the snobbery of the upper classes. Typical is the 1907 painting "Gray and Brass" (figure 2-1). Here, the artist portrays the fashionable superficiality of an opulent industrialist who rides with his entourage of women in an elegant convertible. The passengers' dour, haughty expressions reveal a self-indulgence and social indifference. The younger woman rejects the advances of a sailor as profoundly beneath her. Sloan dramatically reveals his distaste for America's class inequities.

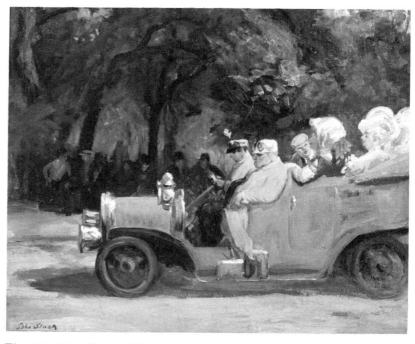

Fig. 2-1. John Sloan, "Gray and Brass," Collection of Arthur G. Altschol, photo by Taylor & Dull Inc., New York.

Sloan's class-consciousness emerges forcefully in a compassionate work, the etching "Roofs, Summer Night" (figure 2-2). The artist's description of working class life in New York City is not merely objective. These people do not go to their roofs seeking amusement; in the suffocating heat and unbearably crowded conditions, their retreat is a physical and emotional necessity.

George Bellows (1882-1925) also figured prominently in the Ashcan school. In his short lifetime, he achieved a reputation that makes him a foremost representative of American artistic realism. A mid-westerner, Bellows was an exceptional athlete, and chose a career in art rather than one in professional baseball. In 1904, he came to New York and quickly became Robert Henri's student. Soon a major artist, Bellows carried the Ashcan banner with a vigor unmatched by his older colleagues. His paintings are exuberant, capturing life's vitality in the Ashcan tradition.

One of Bellows' artistic topics, not surprisingly, was the world of professional athletics. His treatment of sports, especially boxing, remains the most impressive work in that

*George Bellows
(1882-1925)*

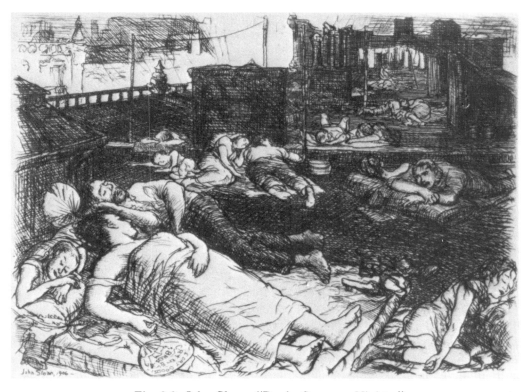

Fig. 2-2. John Sloan, "Roofs, Summer Nights."

genre. Most famous is the 1907 painting "Stag at Sharkey's" (figure 2-3). "Sharkey's" was a New York saloon located near the artist's studio. Because prize fighting was then illegal, Sharkey's operated under the guise of a social club. The management, signing the boxers up as "clubmembers" in good standing, could provide its clientele with the bloody entertainment it craved.

In "Stag at Sharkey's," Bellows captures the fight's energy and excitement; the match is intoxicating, perhaps a pleasant relief from daily life's tedium. Yet Bellows refuses to romanticize his depiction of the crowd. The spectators' undisguised glee emphasizes their primal barbarism as well as that of the fighters. The crowd's ferocity recalls Goya's "Caprices" as Bellows conveys the darker side of human nature and behavior.

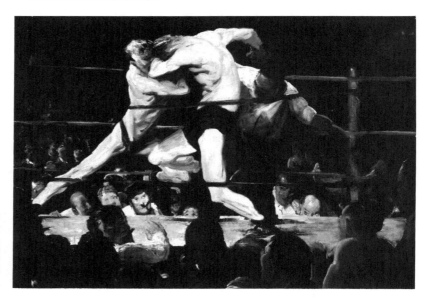

Fig. 2-3. George Bellows, "Stag at Sharkey's," The Cleveland Museum of Art, Hinman B. Hurlbut Collection.

Another major theme in Bellows' art was the depiction of early 20th century tenements. Most important is the 1913 painting, "Cliff Dwellers" (figure 2-4). It starkly portrays conditions facing the residents of New York's Lower East Side. Squalor is omnipresent; there is no privacy or breathing space, and little room for human dignity. The painting makes vivid the difficulties faced by millions of immigrants who came to the United States seeking a measure of economic security and political or religious freedom. Its realistic and humane portrayal makes "Cliff Dwellers" a landmark of socially conscious art in the United States.

A consistent feature of Bellows' art is its ability to reveal social life's tragic effects on the individual. An outstanding example is a drawing entitled "The Drunk" (figure 2-5). Frustrated by his inability to provide for himself and his family, the father turns to alcohol; in the drawing, his children cower

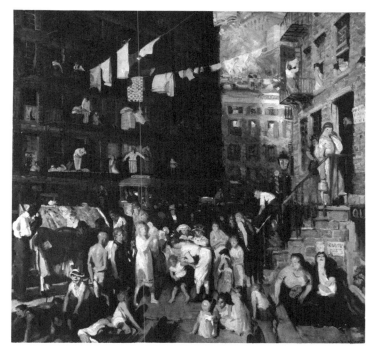

Fig. 2-4. George Bellows, "Cliff Dwellers," Los Angeles County Museum of Art.

while other family members attempt to halt his drunken rampage. Thus the work focuses sharply upon the bitter personal consequences of poverty. Yet our view of this ostensibly private, family matter prompts us to consider broadly the social and economic inadequacies that generate such behavior.

The creation in 1911 of *The Masses* added a major chapter to the tradition of socially conscious art in the U.S. Until 1917, when its leaders were indicted under the Espionage Act for obstructing military recruitment, *The Masses* furthered artistic and political radicalism. Some of the most prominent figures of American letters contributed to the journal, including Max Eastman, Sherwood Anderson, Louis Untermeyer, John Reed, and Carl Sandburg. Like these writers, visual artists produced work for *The Masses* and were active in its editorial managements; thus they voted, along with the columnists, on whether a given piece of writing or artwork would be published.

The founding of *The Masses* marked a shift, echoing the nation's increased radicalism with a more social and political art. The Ashcan painters, although sincerely concerned with social problems, did not call for radical political transformation in the United States. In line with the humanist individualism of Robert Henri, the Ashcan School expressed deep compassion for the downtrodden and extolled the fortitude of the working class. Although historically durable because of its artistic merit and ultimate commitment to humane values, the Ashcan School was eclipsed in political force by *The Masses* and later by the Social Realists of the 1930s.

Fig. 2-5. George Bellows "The Drunk," Addison Gallery of American Art, Phillips Academy, Andover, Mass.

27

Fig. 2-6. John Sloan, "State Police in Philadelphia."

Social Realism

In *The Masses,* Ashcan realism converged with the tradition of political cartooning, the primary medium in the 19th century for artistic social commentary. John Sloan shared the working class attitude of *The Masses* and lent his artistic efforts to the struggle. A *Masses* drawing from 1915 entitled "State Police in Philadelphia" (figure 2-6), reconstructs the occurrence of a street-car strike in that city. The drawing is a powerful indictment of police intercession on behalf of the interests of management. The faint image of a statue of William Penn, overlooking the brutal scene from atop City Hall, adds an element of bitter irony to the work.

Equally powerful is Sloan's "Calling The Christian Bluff" (figure 2-7). On 4 March 1914, several hundred unemployed workers, many hungry and homeless, marched to St. Alphonsus' Church in New York to demand assistance. They were summarily dismissed from the premises. Police were called to remove those who refused to leave and many resisters were arrested and imprisoned. Sloan's drawing captures the indifference and Christian hypocrisy that characterized the event. Thus the artist joins such luminaries as Goya, Daumier, Grosz, and Orozco in the effort to strip from the Church and organized religion the veil of "Christian charity."

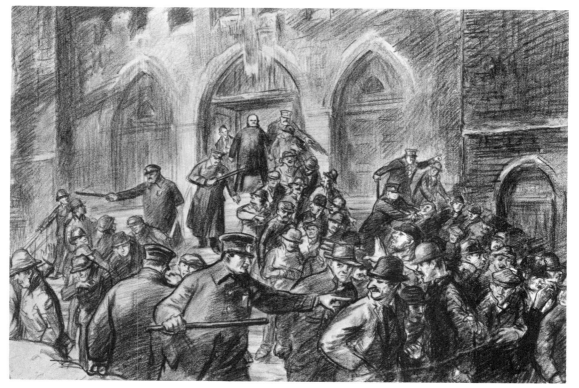

Fig. 2-7. John Sloan, "Calling the Christian Bluff," Collection of Dr. & Mrs. Martin Cherkasky, photo by Geoffrey Clements.

Fig. 2-8. John Sloan, "Before Her Makers and Her Judge," Collection of Whitney Museum of American Art, New York, photo by Geoffrey Clements.

Sloan was an equally perceptive observer of society's secular institutions. His early training as a journalist sharpened his sensitivity to needs of the poor that were constantly thwarted by such minions of bureaucratic society as the police and petty judicial officers. Sloan witnessed the maltreatment of alcoholics beaten with impunity by police. He also attended Night Police Court in New York City, and those sessions inspired an important 1913 *Masses* drawing, "Before Her Makers and Her Judge" (figure 2-8). The work shows arrested prostitutes being processed by the court with machine-

like efficiency. The Judge is not concerned with the social conditions that encourage women to sell their bodies, or with the dubious practice of police entrapment, not to mention that only the woman is considered a criminal; he condemns the female defendant before him. Sloan's art, like Daumier's, criticizes a legal system that values efficiency over justice and one that perpetuates class discrimination.

John Sloan contributed more than sixty drawings to *The Masses* during its brief existence. In 1916, as a result of severe disagreements over editorial policy and conflicts with various editors, he resigned his post as the magazine's art editor. His political activism declined and, although he remained personally dedicated to his own version of democratic socialism, Sloan's art became far less social in nature. By the time of his death, his retreat from the political arena—prompted perhaps by his fallout with *The Masses*—was clearly evident in his artistic production. His work then was comprised mostly of traditional portraits, nude studies, and landscapes. Sloan's early contributions to the tradition of socially-conscious art, however, were enormous and enduring.

Fig. 2-9. George Bellows, "Benediction in Georgia," The Cleveland Museum of Art, gift of Leonard C. Hanna, Jr.

The graphic contributions of George Bellows to *The Masses* are equally impressive. His famous 1917 lithograph "Benediction in Georgia" (figure 2-9) depicts a sanctimonious and paternalistic white clergyman blessing a group of black prisoners. The parson's bombast is highlighted by the convicts' obvious boredom.

An even more powerful Bellows lithograph treating the historical tragedy of U.S. race relations appeared in 1923. Although not published in *The Masses,* "The Law is Too Slow" (figure 2-10) echoes the journal's radical concerns.

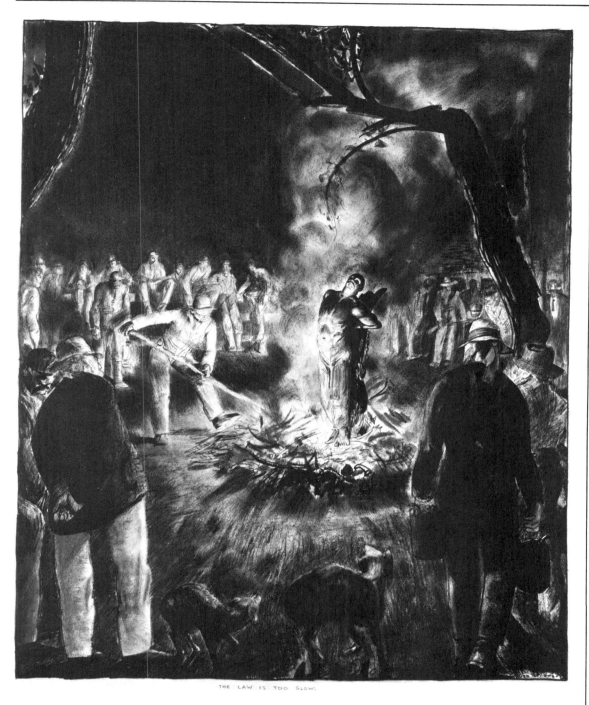

THE LAW IS TOO SLOW.

Fig. 2-10. George Bellows, "The Law is Too Slow," courtesy of the Art Institute of Chicago.

Here, Bellows creates the most stark and horrifying view of lynching since works done by Thomas Nast. The victim's stance recalls traditional depictions of the crucifixion and saintly martyrdom. Spotlit by the artist's chiaroscuro, the doomed man symbolizes a period in United States history during which vigilante "justice," speedier than recourse to judicial processes, was all too common. Since 1859, there have been approximately five thousand lynch mob victims, most of them black.

Bellows' sudden death in 1925 cut short the productive career of one of the most important 20th century artistic realists. Subsequent generations of social and political artists have found inspiration in his precedent-setting work.

Other *Masses* artists also merit consideration. Works produced by such men as Robert Minor, Maurice Becker and William Balfour Ker constitute a major chapter in socially conscious art; notable in their own right, they also exerted a pervasive influence on future political and artistic developments in the United States.

Robert Minor

Minor was the group's most consistently radical political artist and, ultimately, he abandoned his art for full-time activity in the Communist Party. His work fit well with the perspective of *The Masses*. Like his colleagues, Minor frequently dealt with striking workers and the often brutal response of governmental authorities. Typical is the 1916 *Masses* drawing "Pittsburgh" (figure 2-11), which searingly indicts government strikebreakers. Although the drawing's intellectual treatment of its subject is somewhat simplistic, Minor's detail-blurring swift crayon stroke provokes an immediate and true emotional response to the workers' plight. Such propagandistic artistic treatment was in keeping with the journal's object of enlisting its readers in the class struggle rather than in analyzing with great sophistication major issues of the day.

The editorial board of *The Masses* opposed U.S. entry into World War I. It viewed that conflict as beneficial only to international capitalists and speculators, and several *Masses* artists mounted a sustained assault against the United States. Noteworthy is Minor's 1916 drawing "At Last a Perfect Soldier" (figure 2-12), a classic of the genre. Like George Grosz's famous 1918 work, "Fit for Active Service," Minor's cartoon scathingly satirizes a military that seeks men adaptable to army authoritarian life. The "perfect soldier," brutishly strong, is headless; uncritical, he is particularly susceptable to military socialization. Minor's drawing, intentionally hyperbolic, trancends its topical setting by commenting on the bureaucratic mindlessness and suffocating conformity that have long characterized military institutions.

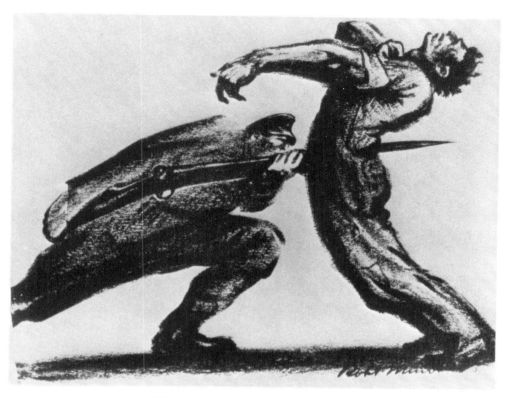

Fig. 2-11. Robert Minor, "Pittsburgh."

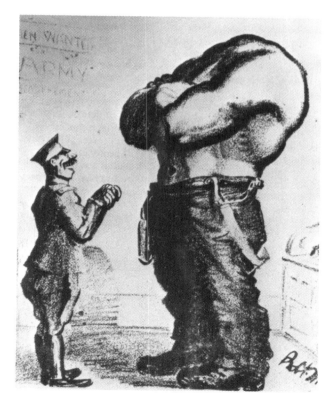

Fig. 2-12. Robert Minor, "At Last a Perfect Soldier."

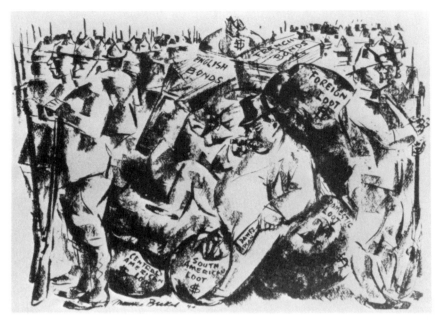

Fig. 2-13. Maurice Becker, "Morgan über Alles."

Maurice Becker
Painter & cartoonist

Maurice Becker, the most artistically sophisticated of *The Masses* illustrators, was a painter as well as a cartoonist. Becker had assimilated artistic styles developed in Europe and was not reluctant to experiment in order to strengthen his social commentary. Exemplary is "Morgan Über Alles" (figure 2-13), done for a successor of *The Masses, Liberator* magazine. The work is markedly cubist. Becker utilizes the capitalist archetype J.P. Morgan—amidst his money and closely protected by U.S. soldiers—to illustrate the military and industrialist alliance.

A Becker cartoon of 1917, "They Ain't Our Equals Yet" (figure 2-14), depicts four gloating men celebrating the defeat of women's suffrage in West Virginia and South Dakota. The artist captures, in the men's self-indulgent smirks, the smug sexual chauvinism that characterized the era.

William Balfour Ker

Another *Masses* artist resolutely opposed to U.S. entry into World War I was William Balfour Ker. His work entitled "The Hand of Fate" (figure 2-15) epitomizes the social militancy of the early 20th century visual arts. Ker contrasts the decadent life of the rich with the burdens of the poor; the entire edifice of privilege rests on the toil of the American proletariat. The hand of fate, of course, is a prophecy of class revolution, and the work demonstrates Ker's generalized compassion for the oppressed. Clearly, such artworks may serve as weapons; their consistent use as such in *The Masses* and in other publications heralded the increased dominance socially-committed art would achieve during the Depression.

Fig. 2-14. Maurice Becker, "They Ain't Our Equals Yet."

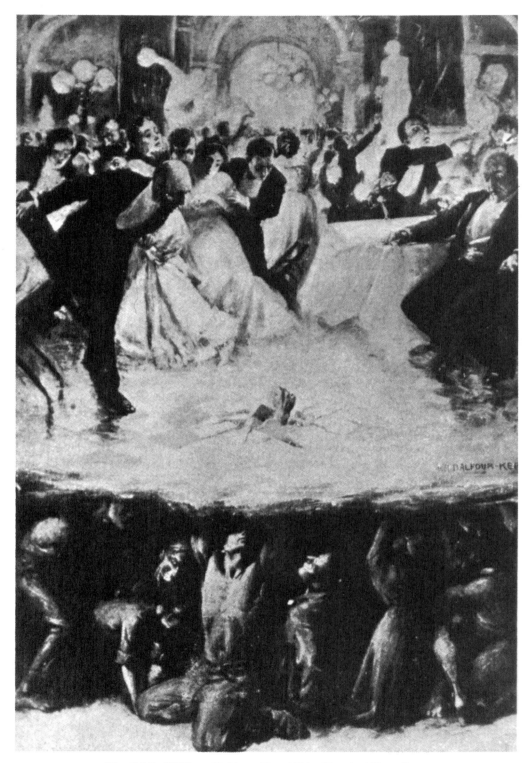

Fig. 2-15. William Balfour Ker, "The Hand of Fate."

The history of the United States between World War I and World War II is a turbulent one. The Red Scare of 1919, the Sacco-Vanzetti case of the 1920s, and the dominant influence of business in political life had incalculable effects on the nation. Nothing, however, was as monumentally important as the Depression, and this chapter will be concerned mostly with artistic production of that catastrophic period.

The postwar prosperity of the 1920s turned quickly into unprecedented economic disaster. Agriculture deteriorated dramatically, and the once-fertile land turned into dustbowls, resulting in the attendant human displacement and suffering described in John Steinbeck's *The Grapes of Wrath*. In 1933, at the time of the first inauguration of President Roosevelt, 25 percent of the labor force in the U.S. was unemployed. The grim pattern of urban bread lines and consequent personal despair dominated life in the U.S. Meanwhile, in Europe, the spectre of fascist totalitarianism became ever more frightening.

The Depression was clearly the dominant age of socially conscious art in the United States. In response to difficult conditions, numerous artists energetically expressed their partisan views. Important groups of such artists are treated here: descendents of the Ashcan school, photographers of the Farm Security Administration, the Regionalists, and the "Magic Realists." Also treated are those artists, perhaps most important of all in the tradition of socially-engaged art, known as the "Social Realists." Finally, the work of several artists independent of these groups will be examined, thus rounding out a history of the art of social conscience through World War II.

The works of Edward Hopper (1882-1967), another of Robert Henri's students, are clearly in sympathy with the Ashcan tradition. Although many critics have deemed him an objective chronicler of urban life and have proclaimed Hopper's works devoid of personal commentary, the artist's careful selection of subject matter demonstrates a highly critical view of U.S. society.

Hopper's work concentrates almost exclusively on the internal, psychological realm of the individual and on the deeply personal consequences of American social life; such a focus contrasted markedly with that of the Social Realists, who dealt primarily with major topical issues of the day and with institutional causes of human despair. Hopper was the first leading United States artist to treat extensively the subject of alienation, seeing beyond the veneer of Roaring 20s high living. Hopper's influence is evident in the later work of such diverse artists as George Tooker, Leonard Baskin, George Segal, and Diane Arbus.

CHAPTER 3

WORLD WAR I TO WORLD WAR II

SOCIAL REALISM & THE FLOWER-ING OF A HUMANIST ARTISTIC TRADI-TION

Edward Hopper (1882-1967)

Hopper often painted the city, depicting it as a forbidding and frightening place, its inhabitants lonely and isolated. These men and women are found in dreary hotel rooms, dingy offices, and on desolate streets. An early example is the 1921 etching "Night Shadows" (figure 3-1). A solitary figure walks silently amidst the shadows of buildings; stark loneliness pervades the work, and the viewer may empathize with the troubling features of this situation.

The somber character of Hopper's vision is carried further in the 1926 painting "Sunday" (figure 3-2). The work permits a view of life in the city for the elderly. Sitting drearily on a curb on a Sunday morning, the aged man has nowhere to turn for amusement or diversion. The empty store behind him underscores his painful isolation. And the brightness of the sun, rather than illuminating, seems mocking.

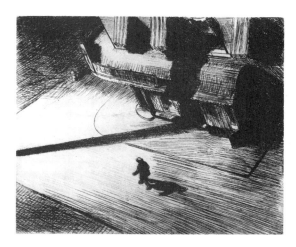

Fig. 3-1. Edward Hopper, "Night Shadows," Collection of Whitney Museum of American Art, New York, photo by Geoffrey Clements.

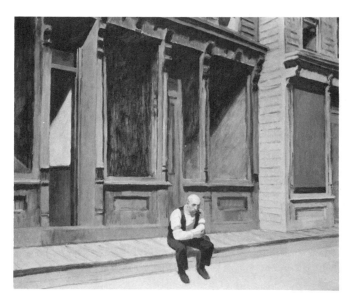

Fig. 3-2. Edward Hopper, "Sunday," The Phillips Collection.

Hopper painted his masterpiece, "Nighthawks" (figure 3-3), several years later. It is the most powerful cohesive summation of Hopper's thematic concerns. The diners at the all-night restaurant are conspicuous in their lack of communication and isolation from one another. Once again, Hopper uses the surrounding buildings' emptiness to enhance the impression of alienation. And he uses light to emphasize the isolation of the four lonely figures. Hopper's disconcerting vision is universal in its application, and could scarcely fail to affect the viewer.

Reginald Marsh (1894-1954) is perhaps the most important descendent of the humanist-realist Ashcan tradition. His paintings and illustrations of city life achieve an even greater power than those of his predecessors, capturing life at its rawest. Eschewing "beauty" for "truth," his art focuses on virtually every feature of lives lived under severe social and economic stress.

*Reginald Marsh
(1894-1954)*

Ashcan Tradition

A large portion of Marsh's work portrays diverse places of escape that pervaded the Depression era: tattoo parlors, 20 cent movies, beaches such as Coney Island, and burlesque houses. Marsh treated sex as openly as had ever been done in American art; academic painters had used only studio models in their efforts to capture classic form, but Marsh, an uncompromising realist, felt the need to paint the figure as seen in the real, often seedy, world. Marsh also recorded such phenomena of the times as the dance marathon, that nightmarish

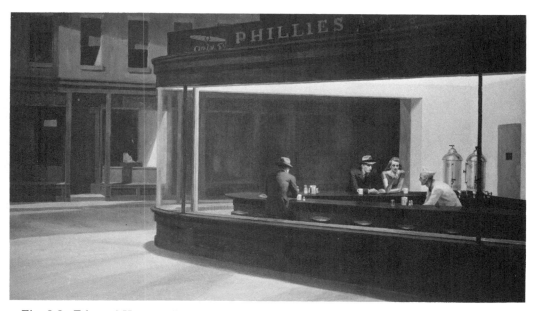

Fig. 3-3. Edward Hopper, "Nighthawks," courtesy of the Art Institute of Chicago.

irony of Depression America. "Zeke Youngblood's Dance Marathon" (figure 3-4), painted in 1932, shows the desperate limits to which people were forced in order to survive. Marsh's intimate view of the grisly spectacle's participants shows dancers, on the verge of exhaustion, miraculously managing to hold on in hopes of earning the few dollars of prize money. The painting is a pictorial counterpart to Horace McCoy's novel, *They Shoot Horses, Don't They?* Taken together, the works serve as a study in the pathology of social life in the 1930s.

Marsh created other images of the Depression, most notably depictions of bread lines and horrifying images of human beings forced to search through garbage cans for food. A painting entitled "Sandwiches" (figure 3-5) captures the degradation of that era when people were reduced to an animal-like existence. The painting's central figure is intent on physical survival, while the others are fortunate enough to cavort on the beach. The painting leaves the viewer shocked and incredulous, disallowing any possiblity of romanticism of Depression poverty.

Even more than his Ashcan predecessors, Marsh used his art to record the lives of people at the lowest level of society. The New York Bowery, teeming with derelicts, is generally ignored by artist and "respectable" members of society alike. Marsh, however, forced a confrontation with realities of derelict life in a series of paintings and prints. Typical is the 1928 lithograph "The Bowery" (figure 3-6), which depicts the community of bums who are nowhere else assimilable and which, for all its filth, is filled with pathos. Like Hopper, the ultimate significance of Marsh lies in his selection of subject matter, which evinces a consistent compassion for the travails of social living.

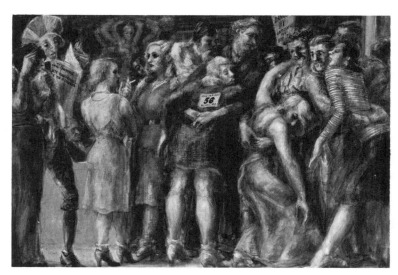

Fig. 3-4. Reginald Marsh, "Zeke Youngblood's Dance Marathon," Munson-Williams-Proctor Institute.

Fig. 3-5. Reginald
Marsh, "Sand-
wiches," Wichita
Art Museum.

Fig. 3-6. Reginald
Marsh, "The
Bowery," The
Metropolitan
Museum of Art,
Arthur H. Hearn
Fund, 1932.

Lewis Hine
Photographer

In order to fully appreciate the work of the Farm Security Administration photographs, it is necessary to consider the precedent-setting photographs of an earlier social commentator, Lewis Hine. Hine, whose career was dedicated entirely to the social vision, was a crusader whose camera exposed the brutalities of U.S. industrial life in the early 20th century. His work personalized the consequences of industrialization and coincided with that of social reformist and muckracking writers like Lincoln Steffans, Frank Norris, and Upton Sinclair. Hine did much to achieve his objective of using his photographs, each of them didactic, to inform the public and to further social reconstruction.

By the end of the 19th century, industrialization had rapidly urbanized the United States. And though it would eventually bring widespread prosperity, the process had encouraged squalor, strife, and massive personal alienation. A Hine photograph of 1910 (figure 3-7) shows a family making garments in a New York tenement. Each member must work to ensure even the family's survival. Little opportunity is available for recreation and other pleasurable activities of family life. The constant struggle takes its toll as economic

Fig. 3-7. Lewis Hine, "Making Garments in N.Y.," from Collections of the Library of Congress

realities affect the family; and, in such an environment, cultural and intellectual development are remote possibilities.

Other forces exacerbated the difficulties of life in the early decades of the 20th century. The influx of European immigrants, for example, worsened crowded tenement conditions in the cities of the Eastern seaboard. And even more appalling was the scandalous pattern of child labor, a subject that would demonstrate Hine's social significance and artistic mastery. In 1900, there were about 1,750,000 children between the ages of ten and fifteen "gainfully employed" in the United States. Boys and girls labored in factories, mines, and fields, often for less than 50 cents a day. Injuries were commonplace, and even fatalities were not uncommon. Nor were legal prohibitions against these practices effectual, for loopholes encouraged widespread evasion.

Hine's reaction to child labor was moral outrage. He traveled throughout the nation in order to expose the tragedies of this blatant social evil, producing scores of gripping photographs. Each condemned the forces that foreclosed the children's prospects of living an autonomous or fulfilling life. An example from 1909 (figure 3-8) has the usual caption, written by Hine, identifying the child and his work. Here, a

Fig. 3-8. Lewis Hine, "Neil Gallagher," Bafford Collection, University of Maryland Baltimore County Library.

boy named Neil Gallagher has worked for two years in a factory and has lost his leg in a crushing machine. The photograph tells the entire gruesome story; additional commentary would be superfluous.

Hine also photographed slums, the terrible conditions of the elderly, and the problems of racial minorities. In Europe, he recorded the plight of homeless beggars and refugees in the aftermath of World War I. And, returning to the United States, his sympathetic portrayals of workers at construction sites expounded the dignity of labor.

The major impetus for the continuation of Hine's photographic legacy was the 1935 creation of the Farm Security Administration.* The United States government agency was largely the idea of Rexford Guy Tugwell, Assistant Secretary of Agriculture and one of President Roosevelt's original advisors from the academic world. Tugwell hired Roy Stryker, a former student and colleague of his from Columbia University. Stryker in turn hired several outstanding photographers whose mission was to document the Depression's impact on Americans and to convince the public of the need for federal help.

Until its termination in 1943, the FSA was responsible for approximately 270,000 photographs that chronicled virtually every feature of U.S. life. Several hundred of these works have become classic examples of socially conscious art. Some of the major figures in American photographic history were involved in these efforts: artists such as Dorothea Lange, Walker Evans, Ben Shahn, Arthur Rothstein, Jack Delano, and John Vachon.

Dorothea Lange (1895-1965) Photographer

Dorothea Lange (1895-1965) made contributions comparable in stature to those of the finest socially conscious painters and graphic artists. One of the giants of her medium, her career spanned more than 30 years and covered a multitude of social topics. Although she had a commercial studio in San Francisco, Lange was most interested in photographing the world outside it. She had always had an active interest in people and a commitment to their feelings and aspirations.

Lange, impelled by her concern, began to use her art to record the public and private agony caused by the Depression. In 1933, the first of her powerful social photographs appeared and established Lange as a premier documentary photographer. Taken in San Francisco, "White Angel Breadline" portrayed an old man bitterly turning his back on a handout. Works such as this impressed Professor Paul Taylor of the University of California at Berkeley, and he invited Lange to join a research project on the problems of migrant laborers. The two, later married, collaborated on such projects through-

*Originally called the Resettlement Administration until its name change in 1937.

out Lange's life.

In 1935, Lange joined Walker Evans and Ben Shahn, among others, in the efforts of the Farm Security Administration. Her most powerful work chronicled the human tragedy of uprooted impoverished Americans moving westward from Oklahoma and Arkansas; it was FSA photographs such as these, in fact, that inspired Steinbeck's *Grapes of Wrath.* These people were pariahs, American counterparts of the "Indian" untouchables. Lange, however, captured the "Oakies" in a remarkable series of photographs that testified to the emotional burdens of social disruption and economic insecurity.

In 1936, Lange produced her most famous and widely reproduced photograph, "Migrant Mother." One in a series of photographs, it is truly a classic of human compassion. Also from that series, Lange shows the woman (figure 3-9) nursing her infant child; they sit in a makeshift tent, part of one of the infamous California migrant camps of the 1930s. Fearful of her future, the mother nevertheless addresses the present, providing both physical and emotional nourishment for her child; her endurance in the face of hardship adds a note of hope.

Most of Lange's FSA works were similarly impressive treatments of the unrelenting misery of migrant life. But she did not neglect to document the solitary anguish of those who chose to remain. A moving example, depicting two unemployed Oklahoma men, was taken in 1936 (figure 3-10). Squatting on the pavement while conversing, it is clear that the men's real thoughts are elsewhere. Their entire lives have been bound to their daily labors. Now, deprived of a major element of identity, they can only wait and hope. Rarely has the psychology of ordinary citizens under stress been as forcefully communicated in a work of art.

Lange spent time in the deep South during her FSA work of the middle 1930s. She took one of her most striking and significant photographs in the Mississippi Delta during 1936. "Plantation Overseer and His Field Hands" (figure 3-11) is a dramatic view of the ruler and the ruled in the old power structure of the rural South. The burly white master dominates the picture, behind him five black men. Significantly, all the parties understand the "system," extending here even beyond the plantation, and appear to accept their roles within it. An exceptional historical source, the work serves as a reminder of racism that continues today.

In 1938-1939, Lange and Taylor collaborated on a book entitled *An American Exodus,* published in 1940. Lange's photographs treated many of the same themes she had recorded earlier and the book is an invaluable aid in understanding the era.

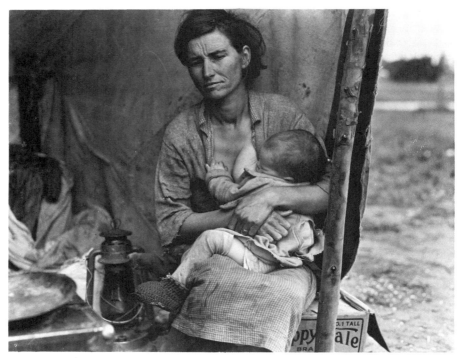

Fig. 3-9. Dorothea Lange, "Migrant Mother Nursing," Collections
of the Library of Congress.

Fig. 3-10. Dorothea
Lange, "Unemployed,
Oklahoma."

Fig. 3-11. Dorothea Lange, "Plantation Overseer."

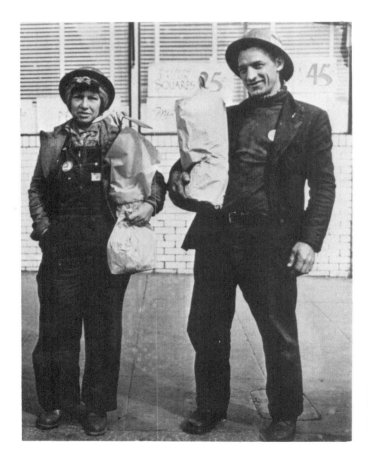

Fig. 3-12. Dorothea Lange,
"Richmond, California,"
Dorothea Lange Collection,
The Oakland Museum.

By the early 1940s, Lange had received recognition as a major U.S. photographer and artist. In 1942, she worked for the War Relocation Authority, photographing the internment of the West Coast Japanese-Americans. Cumulatively, her works reveal the disgraceful treatment accorded the internees and the personal hardships they endured; they echo the artistic efforts of Mine Okubo, discussed below.

In 1942, Lange photographed groups of workers in war-related industries in Richmond, California. A prominent theme within this series is the role of women in the labor force. Heretofore excluded from industrial work, women were necessary for World War II national mobilization. Lange recorded the significance of this situation in a work entitled "Richmond, California" (figure 3-12). She focuses on a couple completing their shopping, both wearing work clothes and identification badges indicating their status as industrial workers. Each carries an equal amount of the groceries, an equality generated by national necessity if not by widespread personal volition. Lange's photograph foreshadows feminist consciousness, emphasizing the women's innate equality.

By the end of the war, Lange had shifted her attention to other topics. In the 1950s, however, she resumed a commitment to socially conscious photography that would last until her death from cancer in 1965. Her career, above all, reaffirmed photography's special utility as a medium for social commentary.

Walker Evans (1903-1975) Photographer

Some of the most powerful and stylistically distinctive FSA photographs were created by Walker Evans (1903-1975). Like his colleagues in the Farm Security Administration, Evans felt the Depression's impact and the obligation to inform the public of America's dispossessed and unemployed.

A serious intellectual, Evans was widely read and travelled by the time he decided to become a professional photographer. He developed exacting standards for himself, and he generally eschewed the use of his talents for merely commercial purposes. Impoverished himself, Evans produced numerous sensitive photographs that easily attained the status of fine art. Most of those works dated from his eighteen month association, beginning in late 1935, with the FSA.

Travelling throughout the South, Evans documented the lives of sharecroppers, focusing on their meager shacks, possessions, and crops. "Sharecroppers' Family" (figure 3-13), one of his most famous photographs, was taken in Alabama in 1936. Barely existing in a stark shanty, the family members are enobled, in spite of their situation, by Evans' recognition of their humanity; the effort fuses human compassion with a broader indictment of the social order.

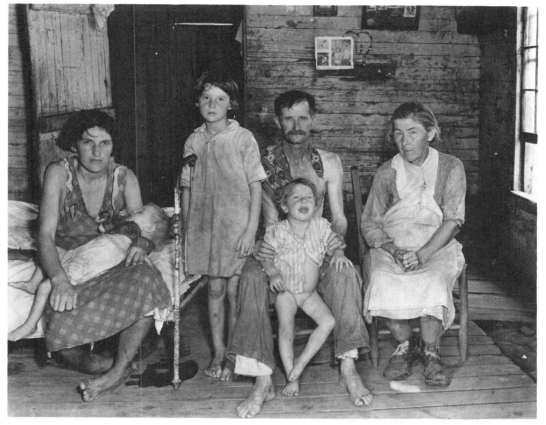

Fig. 3-13. Walker Evans, "Sharecropper's Family," Collections of the Library of Congress.

In a 1936 photograph, "Bed, Tenant Farmhouse, Hale County, Alabama" (figure 3-14), Evans' comment is forceful in its attention to objects rather than people. The work's stylistic economy aptly expresses the barren reality of a sharecropper's life.

"Child's Grave" (figure 3-15) is perhaps the most poignant photograph Evans produced during his travels in the South. The composition's stillness and simplicity provoke thoughtful contemplation, not cheap sentiment, of the ultimate human sadness symbolized by the child's grave; and the work is also a subtle indictment of an economic system that is virtually feudal.

Although Margaret Bourke-White (1906-1971) was not one of the FSA photographers, her photojournalism did achieve the same stature and warrants brief treatment here. During her lifetime Bourke-White photographed wars, political conflicts, revolutions, and hundreds of related events. She consistently used photography as a tool for social criticism.

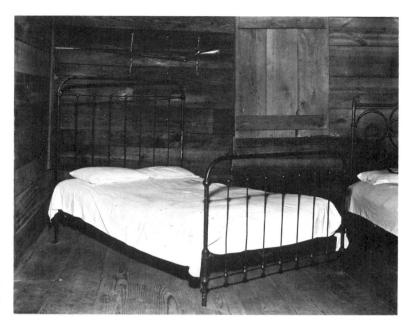

Fig. 3-14. Walker Evans, "Bed, Tenant Farmhouse," Hale County, Alabama.

Fig. 3-15. Walker Evans, "Child's Grave."

During the Depression, Bourke-White toured the South with her future husband, novelist Erskine Caldwell. One of her most gripping efforts is entitled "Tenant Farmer's Wife" taken in Locket, Georgia. The sad expression on the woman's face is a reflection of a harsh and unrewarding life. The woman's comments reveal sorrow: "I've done the best I knew how all my life, but it didn't amount to much in the end."

Bourke-White's other efforts, especially those highlighting the poverty of Southern blacks and cruelties of the criminal justice system, were further additions to the massive body of social photojournalism. And her coverage of World War II was equally astute. Bourke-White's work throughout her career demonstrated that the finest photojournalism can achieve a universal perspective that elevates it to fine art.

The Depression also heralded a school known as Regionalism. Centering largely around the work of Thomas Hart Benton, Grant Wood, and John Steuart Curry, the movement advanced the view that art should emanate from "America," especially local experiences. Extremely nationalistic, Regionalism tended to generate an aggressively narrow provincialism that elevated the experiences and values of the American Midwest. Yet for all that provincialism, it was at times a medium for liberal commentary. Wood was a political liberal, and Benton had had considerable contact with socialist theory and ideology. And Regionalism, a determined reaction against contemporary European art, did represent a movement toward an indigenous, national art.

Regionalism

Grant Wood (1892-1942) was steeped in the tradition of his native Iowa, but was fully capable of critical comprehension as well. His most enduring painting is "American Gothic" (figure 3-16), finished in 1930. It is not clear whether the painting was intended to be satirical. Some critics justifiably have perceived it as the artist's affirmation of rural values, a token of affection for his Midwest neighbors. Yet it is well to note also the painting's critical impact, even in the possible absence of artistic intention. For close examination of "American Gothic" may reveal a narrowness and limited vision of the two figures. Their dour and sterile expressions indicate a humorlessness and a Bible Belt acerbity toward outsiders.

Grant Wood (1892-1942)

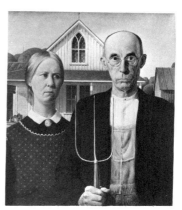

Fig. 3-16. Grant Wood, "American Gothic," courtesy of the Art Institute of Chicago.

A 1932 painting dispels any doubt regarding the satirical side of Wood's love-hate relationship with the Midwest. Wood had earlier been verbally attacked by the Daughters of the American Revolution, and had said: "They could ladle it out. I thought I'd see if they could take it."

His retaliatory "Daughters of Revolution" (figure 3-17) is

Fig. 3-17. Grant Wood, "Daughters of Revolution," estate of Grant Wood.

Thomas Hart Benton (1889-1975)

a sardonic view of three reactionary, elderly women whose sole claim to status is the fortuity of their ancestry. Reminiscent of Goya's savage portrait of Queen Maria Luisa of Spain, Wood's use of detail heightens the painting's impact. Thus the woman in the center holds a teacup with contrived delicacy, a gesture that only emphasizes her absurdity. Even more significant is the background view of Leutze's famous painting "Washington Crossing the Delaware." For all his heroic romanticism, Leutze at least captures the bold, adventurous spirit of the Revolutionary War. The degeneration of that spirit into the embarrassing near-senility and suggestive myopia of the D.A.R. women bespeaks a declining nation.

Thomas Hart Benton (1889-1975) had more ambitious objectives than his Iowa colleague and was more thoroughly committed to the development of an American art. After World War I, he turned from European modernism to a Regionalist style, and sought to paint an epic portrait of his country's history, social life, and manners and customs. An accomplished muralist as well as an easel painter, Benton created works consisting largely of historical narratives extolling the traditional virtues of hard work and patriotic allegiance; the harsher truths portrayed by the Social Realists were largely ignored in his art. Nevertheless, there were elements in his work that are worthy of serious consideration in a history of U.S. socially conscious art. While ignoring such topics as poverty and political oppression, Benton did portray

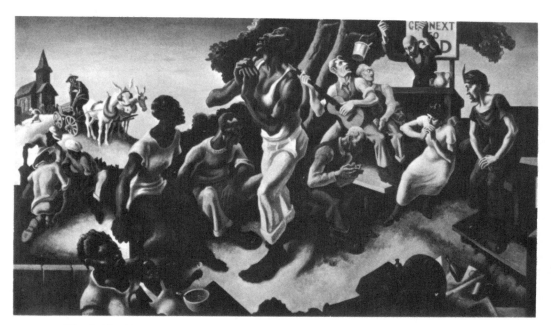

Fig. 3-18. Thomas Hart Benton, "Arts of the South," the New Britain Museum of American Art, Harriet Russell Stanley Fund.

such ugly episodes in the country's history as lynchings and tarrings and featherings.

A strong believer in American ideals of equality, Benton held views on race that were a progressive departure from 1930's national attitudes. "Arts of the South" (figure 3-18), completed in 1932, depicts the cooperation of blacks and whites in various local endeavors. Most notable is the sympathy with which blacks are portrayed. Infused with Benton's characteristic vigor, the work is a modest antidote to racist stereotypes perpetuated even in "respectable" contemporary publications.

Another significant strain of socially conscious art, "Magic Realism," included several artists whose works combined social commentary with surrealistic, bizarre images to create a kind of hyper-realism.

Magic Realism

Ivan Albright (1897-) created one of the more unusual styles in modern art. During his army service in World War I, Albright was employed to make meticulous medical drawings. This experience influenced his later tendency toward vivid, repulsive portrayals of human flesh. In contrast to the Social Realist artists, Albright apparently resigned himself to the pervasive despair of human life. His belief was that existence is replete with senseless frustration and hardship and his art, socially critical, demonstrated a compassion for such suffering.

*Ivan Albright
(1897-)*

Typical is "Into The World There Came a Soul Called Ida" (figure 3-19). The painting shows both the artist's unor-

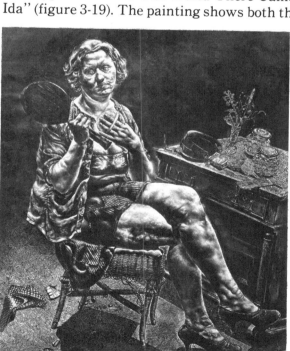

Fig. 3-19. Ivan Albright, "Into the World Came a Soul Named Ida," courtesy of the Art Institute of Chicago.

thodox style and the consummate sadness of the subject matter. Ida's sagging flesh marks the effects of being worn down by the pressures and sorrows of living. Sitting at her dresser, Ida tries to recapture an image of her earlier years. Although her efforts are in vain, her resiliency qualifies the painting's pessimistic overtones; and even as Albright condemns society's indifference to Ida's existence, he suggests that people can survive with at least some measure of personal dignity.

Peter Blume (1906-)

Peter Blume (1906-) is another artist identified with Magic Realism. Born in Russia, he came to the United States as a child. As a young artist traveling in Italy during the early 1930s, Blume was exposed to the depravity of Mussolini's fascist regime. Upon returning to the United States, he painted the satirical "Eternal City" (figure 3-20). By far Blume's most important work, this condemnation of Mussolini is one of the finest examples of political satire in the visual arts.

The viewer is first struck by the vivid green head of the dictator, who is portrayed as a jack-in-the-box popping up from the bottom of the Roman Coliseum. But the revelation of the Italian dictator as a clown and buffoon is only part of the tale.

More sinister features of Italian fascism are revealed elsewhere in the surrealistic painting. Below Mussolini are two supporters, a shady capitalist and a common hooligan. On the left, a crippled and poor elderly woman sits among the once-glorious Roman ruins, the rubble emphasizing the degeneracy of the regime. In the background Roman forum, Blume portrays mutinous soldiers, tokens of the artist's desire for the overthrow of Mussolini. This painting, both complex and obvious, is a rare example of topical art that has endured. Indeed, in retrospect, its impact has increased. As with Picasso's "Guernica," "The Eternal City" alone would be sufficient to establish Blume as a major artist of social conscience.

Paul Cadmus (1904-)

The Magic Realist Paul Cadmus (1904-) created some traditional social protest art, and some as merciless as any produced in the United States. One of his most brilliant examples is the 1934 "Coney Island," a remarkable painting that captures the more degenerate, escapist attitudes of the Depression era.

Another work brought Cadmus into direct and dramatic conflict with governmental authorities. For a 1934 exhibition at the Corcoran Gallery of Art in Washington, D.C., Cadmus executed a print entitled "The Fleet's In" (figure 3-21). Done under the auspices of the Public Works Art Project, the work is a sardonic view of sailors on leave. Several navy men are shown cavorting with willing collaborators, women of plainly

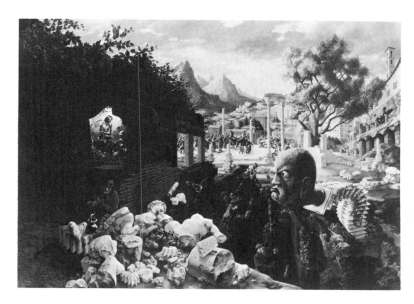

Fig. 3-20. Peter Blume,
"The Eternal City,"
Collection of the
Museum of Modern Art,
New York, Mrs. Simon
Guggenheim Fund.

Fig. 3-21. Paul Cadmus, "The Fleet's In."

dubious reputation. The print tears asunder the myth of moral righteousness promoted by the Armed Forces. When a retired admiral saw "The Fleet's In," he was appalled. Calling the work disgraceful and sordid, he convinced the Secretary of the Navy to have the print removed from the exhibition. Thus the problem of political censorship, endemic in the history of socially conscious art, had resurfaced, as it often does when commentary cuts uncomfortably close to the truth instead of promoting a more pleasant facade.

Another movement, Social Realism, was clearly the most influential development in socially conscious art in the period

Social Realism

*Ben Shahn
(1898-1969)*

between World War I and World War II. The category "Social Realism" is imprecise since artistic styles within the group varied substantially. "Realism" in the visual sense, moreover, is somewhat of a misnomer, for serious attention was rarely paid to replication of visual detail. The Social Realists frequently exaggerated the features of human figures, landscape, and objects, and color was used to heighten the emotional impact of their work. For these artists "realism" entailed preoccupation with real human events. Nor should the term "Social Realism" connote objective, dispassionate reportage, for these artists were far from dispassionate. They shared compassion for the poor, the oppressed, and the working class. Unlike such artists as the Regionalists, for whom overt political commentary or didacticism was the exception rather than the rule, the Social Realists produced works that advocated substantial social and political change.

The finest representative of the Social Realists is Ben Shahn (1898-1969), who merged art with ethical and political commitment. Born in Lithuania, he grew up in Jewish Brooklyn in an atmosphere of social radicalism and with a strong repugnance of injustice. This background would affect his art throughout his entire career. For many years, art historians viewed Shahn and the other Social Realists as mere propagandists, an attitude that has now largely dissipated. Shahn has received the major critical acclaim he properly deserves. Shahn's art is propagandistic. But it combines outstanding technique with enduring themes and is founded on a complex and sensitive intellectualism.

After studying at New York University and City College, Shahn went to Europe for further training. While he was there, two Italian-American anarchists, Nicola Sacco and Bartolomeo Vanzetti, were executed in Massachusetts for allegedly having committed murder and robbery. The case of the two men was to have an enormous impact on the future development of Shahn's art; indeed, his decision to portray their plight marked his emergence as a painter of social protest.

Sacco and Vanzetti's execution was the logical culmination of the Red Scare that had marred the history of the 1920s. For several years, communists, socialists, anarchists, labor organizers, and even many immigrants were relentlessly persecuted by public authorities. Fear of radicalism and xenophobia reached horrifying levels from 1919 to 1921, facilitating Attorney General Palmer's roundup of thousands of people, many of whom were beaten and, without due process of law, deported.

Sacco and Vanzetti were doubly suspect. Both had long records as labor organizers and both had fled to Mexico in order to avoid conscription in World War I. Their trial, during

which witnesses testified the two men were not at the scene of the crime, was conducted with little regard for procedural fairness. The judge never concealed his animosity for the defendants, his rulings were flagrantly biased, and he repeatedly permitted the prosecutors to inappropriately remark upon the defendants' radical social views. Under these circumstances, both men were found guilty.

The case generated widespread public controversy and as the tedious seven year process of appeals continued, scores of protest rallies were held throughout the United States and Europe. Many concluded that Sacco and Vanzetti went to their deaths because of their political beliefs and because of the nation's rampant xenophobia. Intellectuals, artists, workers, and literary figures rallied to the cause. Shahn, too, viewed the case as a miscarriage of justice and became active in demonstrations upon returning home.

Before his portrayals of the Sacco-Vanzetti case, Shahn had, in Europe, completed works that were professionally executed. Yet, as he later indicated in his book *The Shape of Content,* mere technical proficiency was not enough, for there was really little of Ben Shahn in those efforts. The anarchists' execution had aroused in him the urge to combine his art with personal moral consciousness. That consciousness demanded, at every level, a political commitment. This was in fact the major premise of all U.S. Social Realism.

Although other artists such as Rockwell Kent and Maurice Becker had also treated the Sacco-Vanzetti case in their art, Shahn's 23 paintings are the most comprehensive. An excellent example is the 1932 painting "Bartolomeo Vanzetti and Nicola Sacco" (figure 3-22), completed five years after the

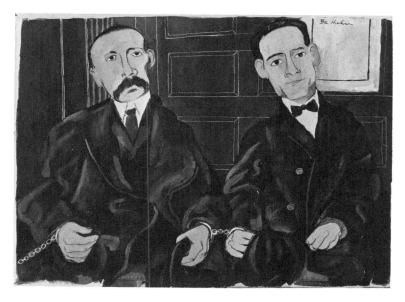

Fig. 3-22. Ben Shahn, "Bartolomeo Vanzetti & Nicolo Sacco," Collection of the Museum of Modern Art, Gift of Abby Aldrich Rockefeller.

men's execution. This sympathetic portrait, emphasizing the human element, transcends a view of the men as mere symbols of a larger cause. Their sad expressions reveal the quiet dignity with which they approached their martyrdom; they are seen as gentle and simple men whose suffering was the result of their sincere attempts to improve the lot of their fellow workers and immigrants. The work's humanism epitomizes the Social Realist movement in general.

Shahn, of course, did not neglect the political issues the case raised. The famous painting "The Passion of Sacco and Vanzetti" (figure 3-23) shows members of the Lowell Commission standing in mock piety over the bodies of the martyred anarchists. The Commission, headed by Harvard University President A. Laurence Lowell, had concluded that Sacco and Vanzetti's trial had been fairly conducted and that their sentence was just. Shahn's painting bitterly rejects that view. He deliberately characterizes the Commission members as cowardly collaborators in a politically-motivated act of injustice. In the background, Judge Webster Thayer's falsely pious portrait recalls his share in the responsibility for the execution.

Fig 3-23. Ben Shahn, "The Passion of Sacco & Vanzetti," © estate of Ben Shahn.

Shahn followed the Sacco-Vanzetti series with a 1933 group of paintings on the case of the persecuted labor leader Tom Mooney, whose frame-up had captured the attention of Diego Rivera; the renowned Mexican muralist then invited Shahn to work as his assistant on the controversial mural in Rockefeller Center.

The Depression, meanwhile, was becoming increasingly severe. Shahn used his art to record the sufferings of people caught in economic circumstances beyond their understanding and control. For example, "Dust" (figure 3-24), completed in 1936, shows a distraught farmer reading the news of yet another dust storm. Overwhelmed by circumstances, he sits, head in hands, pondering a frightening and uncertain future. The poignancy of the work is increased by the presence of the child in the background, anxiously watching his father. Shahn, by personalizing the consequences of poverty, provides an extraordinary glimpse of individualized despair.

A political being, Shahn profoundly augmented his engaged sympathy for the victims of the Depression with a critical perception of those manipulating widespread public discontent for nefarious ends. His treatment of Huey Long is an excellent case in point. The Louisiana politician, known nationally as the "Kingfish," was the head of a "share-the-wealth" movement in the United States during the mid-30s. Exploiting progressive-sounding populist rhetoric, Long and his supporters in fact sought to establish a fascist alternative to U.S. democracy. Long was assassinated in 1935, but the movement was soon joined by such notorious anti-Semites as

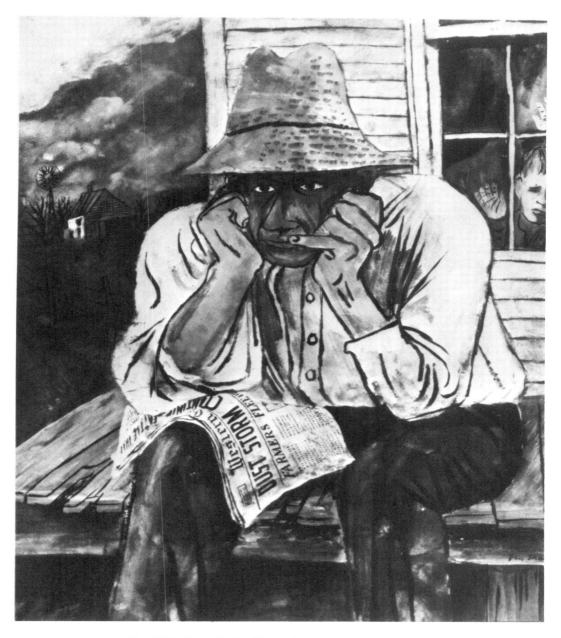

Fig. 3-24. Ben Shahn "Dust," © estate of Ben Shahn.

Gerald L.K. Smith and Father Charles Coughlin. Shahn's satirical portrait of the "Kingfish" (figure 3-25) is an artistic assault on political demagoguery. Savage in its denunciation of the late politician himself, the work is also a generalized warning concerning tyranny that masquerades as social progress.

Shahn's revulsion at the Nazi horror was powerfully expressed in numerous paintings and graphic works. His activity as director of graphic arts for the CIO was similarly important in adding to the burgeoning tradition of artistic social commentary in the U.S.

In the postwar period, Shahn worked often in a style he called "personal realism." He sought through portraits and narrative painting to explore the "inner objectives of art" and to examine that part of individual experience less intimately conditioned by social forces. He never neglected his social commitments, however, and his later art eclipsed in quality even his finest works executed between the World Wars. That later work, beyond the scope of this chapter, will only be summarized here.

In the late 40s, Shahn commented on Illinois' Centralia Mine Disaster in angry and compassionate works. And in 1948 he was active in the Progressive Party presidential campaign of the leftist Henry Wallace. Shahn's masterly "A Good Man is Hard to Find" (figure 3-26) depicts Wallace's oppo-

Fig. 3-25. Ben Shahn, "Huey Long," © estate of Ben Shahn.

Fig. 3-26. Ben Shahn, "A Good Man is Hard to Find," Kennedy Galleries, New York.

nents, Truman and Dewey, as entirely indistinguishable, the frozen smile of each man betokening the insincerity of his campaign rhetoric; saloon pianist and cabaret singer, the politicians perform the same song of opportunism.

In the early 50s, Shahn portrayed victims of McCarthy hysteria and executed lithographs satirizing members of the notorious House Un-American Activities Committee, a group that had scrutinized Shahn's own political involvements. Other work during the Cold War period included a powerful series, *The Lucky Dragon,* which treated moral and political issues raised by nuclear weapons testing. Shahn again emphasized the controversy's human element, focusing on the grief experienced by innocent, radiation-poisoned Japanese fishermen.

Shahn also attacked Francisco Franco and Spanish fascism in a 1956 painting, "Goyescas," the title of which recalls the Spanish master. He expressed opposition to right wing Barry Goldwater's presidential campaign of 1964. In 1965, he commemorated the murder of Mississippi civil rights workers Cheney, Goodman, and Schwerner in a portfolio of prints. Finally, near his death in 1969, the great master used his art to protest United States involvement in Viet Nam.

Ben Shahn was only one of many major artists whose work consistently reflected a social vision. Although lacking Shahn's eminence and public recognition, the following artists are nonetheless significant figures in U.S. art.*

Raphael Soyer (1899-) executed some of the Depression's most psychologically penetrating paintings. A Russian immigrant, he was one of three brothers who also became artistically prominent and who also were involved in the Social Realist movement. A member of the radical John Reed Club in the early 1930s, Soyer met and was influenced by Diego Rivera. Having himself endured poverty, Soyer's interests and sympathies led him to portray fervently the era's dominant topic, the plight of the poor and unemployed.

*Raphael Soyer
(1899-)*

Soyer's political perspective was radical, but not dogmatic. His Depression art was above all a humanistic expression of deeply felt compassion. Soyer repeatedly portrayed the despairing men idle on the streets and in the parks of New York City. One of his finest efforts, "In The City Park" (figure 3-27), was painted in 1934 at the height of the era's economic and social uncertainty. The expressions of the men reveal the intense guilt they experience, outcasts incapable of supporting themselves and their families. Like these men, millions of Americans considered their situation a personal moral failure

*For an extended discussion of themes in the work of Ben Shahn with a focus on works of art not covered in this book, see Chapter 5 of *The Art of Social Conscience,* Universe Books, 1976.

Fig. 3-27. Raphael Soyer, "In the City Park."

rather than the result of institutional breakdown. Soyer's painting is a haunting vision of the collective malaise of the era. The work also reflects the debilitating effects of enforced boredom, another of the often-ignored psychic consequences of poverty.

The 1930s were Soyer's most productive period in the area of socially conscious art. In addition to works depicting effects of the Depression, he also treated the 1936-39 struggle in Spain against Franco's fascist rebellion. "Workers Armed" (figure 3-28) was encouraged by the political ferment among artists during the Spanish Civil War; along with students, intellectuals, and workers worldwide, many artists had passionately supported the Loyalist cause and several even enlisted in the International Brigades. In Soyer's painting a people's army of working class men and women resolutely opposes the fascist assault. Forceful and direct, the work is an invaluable historical source in the effort to understand the Spanish Civil War's immense emotional impact on the latter part of the 1930s.

Raphael Soyer continued his dedication to realism, in opposition to the dominance of abstract art. Some recent paintings depicted life in Greenwich Village, while others were sensitive portraits of literary luminaries such as Allen Ginsburg, Gregory Corso, and Diane Di Prima. His continued dedication to art as an expression of the human experience has made Soyer one of the outstanding representatives of social concern in the visual arts.

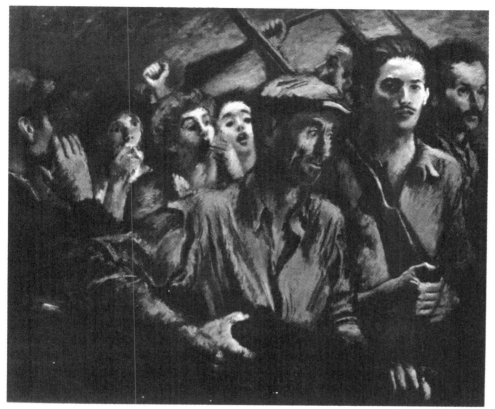

Fig. 3-28. Raphael Soyer, "Workers Armed."

William Gropper (1897-1978) also made a significant contribution to the triumph of socially conscious art during the Depression. Born into the teeming ghetto of the Lower East Side, where both his parents worked in the notorious sweatshops of the early 20th century, Gropper infused his art with a class consciousness throughout his career.

His early work as a cartoonist conditioned his choice of socially critical subject matter in other media. Gropper was the featured cartoonist and pictorial satirist for the *New Masses,* influential in the 1930s, successor to *The Masses* and *Liberator.* The *New Masses* attracted literary contributions from such famous American writers as Theodore Dreiser, Richard Wright, John Dos Passos, and Ernest Hemingway. The journal contributed much to the era's creative ferment.

Although most of Gropper's cartoons are ephemeral comments on topical issues, some achieved a more universal character. A fine example is entitled "Dishwasher" (figure 3-29). Here, Gropper focuses on a marginal worker in a grimy restaurant. Fortunate to have any job at all during the Depression, the man must nevertheless labor under debilitat-

*William Gropper
(1897-1978)
Cartoonist & painter*

ing conditions. Gropper contrasts the worker who stoops over an endless pile of dishes with the supervisor who smokes his cigarette in callous indifference. Transcending its topical reference, "Dishwasher" is a larger view of alienated and degrading work anywhere.

Gropper also received rigorous training as a painter, and developed a distinctive style. His works are the result of a conscientious craftmanship. He sought to evoke public response to society's glaring ills—the graft and corruption of politics, the lot of poor farmers and workers, and the pomposity of the American middle class. Like Shahn and the other Social Realists, Gropper has sometimes been dismissed as a social propagandist. A deeper consideration of his art, however, reveals a masterful technique that vigorously expresses enduring social concerns.

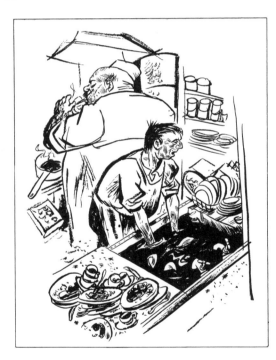

Fig. 3-29. William Gropper, "The Dishwasher."

Gropper regarded the United States Senate as the world's greatest show, and produced a sardonic series of paintings and lithographs depicting Congress. Typical is the painting "Opposition" (figure 3-30), a view of a political windbag and his audience of bored Congressional colleagues. The sleeping senator and two others chatting underscore the disinterest of all the politicians as well as the vacuousness of the speech itself. Like Daumier, who similarly parodied the French National Assembly, Gropper uses visual satire to suggest that legislators are more concerned with self-satisfaction than with the welfare of their constituents.

"Refugees" (figure 3-31), completed in 1937, captures the

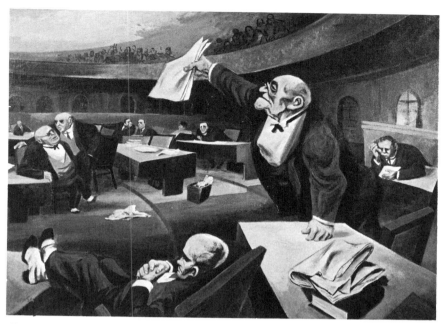

Fig. 3-30. William Gropper, "The Opposition," Memorial Art
Gallery, Marion Stratton Gould Fund.

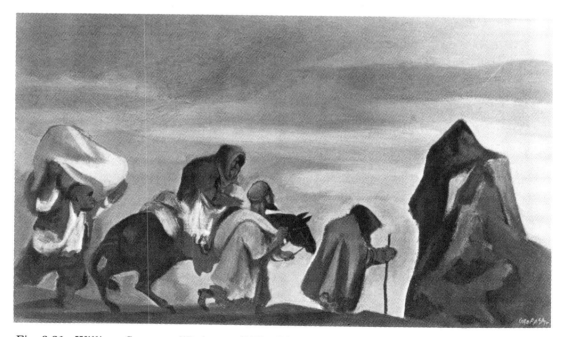

Fig. 3-31. William Gropper, "Refugees," The Phillips Collection, Washington.

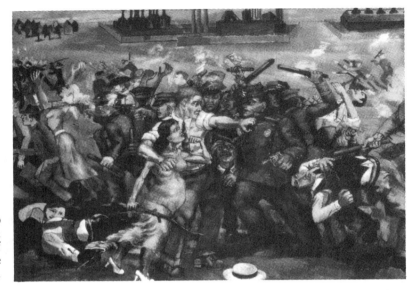

Fig. 3-32. Philip
Evergood, "American
Tragedy," courtesy of
Sue Erpf Van de
Boren Kamp.

tragedy of war and its effects on innocent civilian popula-
tions; people made homeless by circumstances beyond their
control and uprooted and tormented, they must leave behind
all they have ever known.

Gropper's other works, including satiric treatments of
callous industrialists, brutal dictators, and foolish art pat-
rons, have become landmarks of the genre. William Gropper
has occasionally been described as an American Daumier; for
both used their talents, durable beyond satire, to ridicule
corrupt institutions and to point the way to reform.

*Philip Evergood
(1901-1973)*

Philip Evergood (1901-1973), a native New Yorker, is
especially notable for his treatment of the labor strife that
dominated the troubled era of the 1930s. Organized labor had
been suppressed and hated in the U.S. During Roosevelt's
New Deal administration, however, progressive legislation
such as the Wagner Act helped labor unions to obtain recogni-
tion from U.S. corporate giants; the labor movement was at
that time a progressive force. As unions sought earnestly to
achieve justice for U.S. workers, they received widespread
support from well-known writers and artists.

The struggle was not without violence. Bloodshed became
a hallmark of labor-management relations, and police were
often employed in the interests of management. Professional
strikebreakers were used to defeat the organizing efforts of
labor unions. An incident on Memorial Day, 1937, gave rise to
one of the most important artistic efforts in the Social Realist
tradition. Roughly a thousand workers at Republic Steel
Company in Gary, Indiana and their families attended a
steelworkers rally. A protest march to the plant was planned,
but the demonstrators never reached their destination, for
they were met by a large police contingent. Without provoca-

tion, the police charged the crowd with tear gas, clubs, and bullets, killing many of the marchers.

Evergood responded with a masterpiece of artistic protest. Carefully reconstructing the events, he produced a painting that both championed the workers' cause and reflected the turbulence of the times. "American Tragedy" (figure 3-32) is a condemnation of police brutality. In the center stands a defiant worker, protecting his pregnant wife from the savagery of the police attack. The worker is a symbol of the labor movement's resolve to continue to organize. In the background, the distance between the factory and the marchers symbolizes the extent of the journey that remains.

A 1937 painting further validated Evergood's reputation as one of the finest Social Realists. "Mine Disaster" (figure 3-33) typifies Evergood's style, evoking both the real and the surreal. Typical too is the complexity of the composition and subject matter. The work is a tryptych, although without formal division into separate panels. On the left is a view of routine mining operations such as drilling and transportation of metals. On the right is the mine disaster itself. The cave-in crushes a miner, evident only by upraised hands which symbolizes the situation's hopelessness.

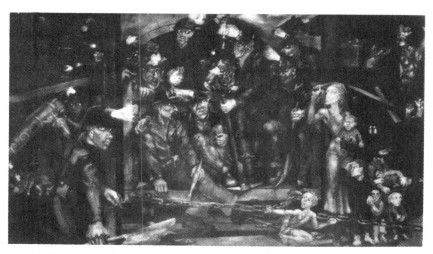

Fig. 3-33. Philip Evergood, "Mine Disaster," courtesy of
Fashion Institute of Technology.

The center part of the painting shows a group of miners seeking to rescue their buried comrade. At right, the newly-widowed woman and her children highlight the event's pathos. The work is a somber treatment of a little-changed industrial reality that has recently been recorded in the documentary film, Harlan County, U.S.A. Somewhat strained in its attempt to evoke the viewer's response—and perhaps overly complex in its structure—the work nevertheless reveals the artist's compassion and commitment.

Evergood continued his social commentary until the end of his career. Treating such topics as alienated labor, aspects of U.S. culture, and the plight of Loyalist prisoners still incarcerated in Spain, Evergood demonstrated the continuing vitality of the Social Realist movement.

Social Realism's unyielding didacticism and its constant belief in art as a tool for social change has led many critics to dismiss the movement from serious consideration. It is true that some of the Social Realists permitted the intensity of their political commitments to impinge on the technical proficiency of their work. Many, too, allowed a simplistic, newly-found Marxism to reduce the intellectual precision of their commentary. Yet it is well to note that the vast majority of Social Realists did manage to fuse proficient technique with socially relevant content. That so many of their 1930's products retain a great impact attests to the tradition's vigor and universality.

Rockwell Kent

Other socially conscious artists, whose work falls into no clearly established category, abounded during the era. Rockwell Kent, an early member in the circle of Robert Henri, retained a progressive political perspective his entire life. During the agitation and turmoil of the 1930s, when hunger, economic breakdown, and the threat of fascism were omnipresent, Kent created numerous socially perceptive graphic works. Active in various artists' organizations, he also supported such causes as the movement for Puerto Rico's independence and the struggle of Spain's Loyalist government. His posters on Spain's behalf were memorable contributions to the socially conscious ferment of the times.

Like most artists, Kent was horrified by the Nazis' brutal military advances throughout Europe and responded in critical fashion. An outstanding example (figure 3-34) shows a hanged and strangled man, symbolizing Nazi victims in general, bound to the swastika. Beneath the corpse is the relentless list of nations having fallen to the Nazi military onslaught: Czechoslovakia, Poland, Greece, Denmark, Holland, Belgium, France, and so on. Ominously, only the U.S.S.R., England, South America, and the United States remain to be crossed off the German master list. The drawing served as a chilling warning to the Western democracies to mobilize their forces in determined anti-Nazi resistance.

Giacomo Patri

Giacomo Patri, not as well known as his more famous contemporaries, was responsible for an intriguing addition to the vast body of social art of the Depression. As a young unemployed artist in San Francisco, Patri experienced first-hand the frustration of being forced to live in substandard housing while struggling desperately to feed himself, his wife, and his three small children. Striving for broader political solutions, Patri concluded that only a united front of

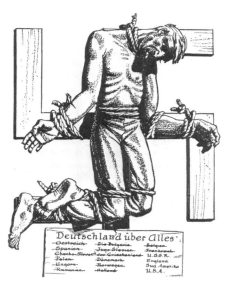

Fig. 3-34. Rockwell Kent, "Deutschland uber Alles," courtesy of the Rockwell Kent Legacies.

Fig. 3-35. Giacomo Patri, final page from *White Collar,* courtesy Mrs. Tamara Patri. Photo courtesy of Research Library, UCLA.

organized labor could exert sufficient political pressure to end the social and economic crisis. He was disturbed that most white collar employees were reluctant to perceive themselves as workers and affiliate with organized labor.

Patri's strong feelings about this erroneous white collar perception impelled him to undertake one of the most ambitious projects of socially conscious art in the American experience, a visual "novel" in linocuts that passionately advocated unity among blue and white collar workers.

"White Collar" became a classic artistic and social product of the Depression. With an introduction by Rockwell Kent and an epilogue by John L. Lewis, the work added a new perspective on the national problems of poverty, human hopelessness, and institutional failure. Long out of print, the novel has recently been republished by Celestial Arts Publishing Company, making it possible for others to examine its artistic merits and to gauge its historical significance. Of its more than 100 prints, it is impossible to select an individual work that is representative. The final page (figure 3-35), however, provides an effective visual presentation of the artist's major premise. Here, Patri depicts a united front of workers surging forward in a display of massive political strength. The work is a passionate comment on clerical and professional workers' foolish delusion that they are somehow superior to manual laborers. The print, moreover, is an excellent example of the optimism that prevailed among so many of the era's socially committed artists; and its message, though providing a panacea, is enduringly valid.

Any history of the art of social conscience through World War II would have to include works that emanated from the "wartime relocation" of Japanese-Americans. In 1942, the United States government, already at war with Japan, forced 110,000 U.S. residents of Japanese ancestry to go to remote camps scattered throughout the western and southern United States; 70,000 of these Japanese were U.S. citizens who were dislodged from homes and jobs in the Pacific Coast states of California, Washington, and Oregon. "Relocation" was effected pursuant to Executive Order 9066, signed by President Roosevelt.

The rationale for the creation of the camps was that the Japanese-Americans were a potential danger to United States military security during wartime. In retrospect, this justification is generally perceived as transparent sophistry, designed to deflect attention from more basic social and historical factors. There had been a long history of anti-Asian sentiment on the West Coast, particularly against the Japanese. That many Japanese immigrants had prospered in business and agricultural ventures only exacerbated existing racism among the dominant population. By 1919, land owned and efficiently farmed by the Japanese produced more than 10 percent of the dollar volume of California crops; unsurprisingly, it was those who had most to gain economically, white farmers, who later called loudest for Japanese relocation. World War II and the bombing of Pearl Harbor provided a convenient pretext to turn racist sentiment into overt racist action. Important sources of public opinion, notably the Hearst newspapers, created pressure to force Japanese-Americans out of their homes and businesses.

After the exclusion orders were promulgated, the Japanese were forced to liquidate their holdings in haste. Consequently, they suffered incalculable financial losses, selling at times for less than 10 percent of the actual value of their property. Those who "purchased" such property received the windfall of racial discrimination.

Another odious consequence of the relocation was the severe emotional fallout experienced by the internees. Even worse than the often deplorable physical conditions at the camps—noted in the Army's own reports—were the psychological burdens of confinement and being constantly under suspicion. Artistic activity, however, lightened some of the load. Amid the dismal existence of regimentation, traditional Japanese crafts such as flower arrangement, calligraphy, and wood carvings abounded. In addition, paintings and drawings chronicled the ugly realities of the camp life; such works are powerful accusations of the racist policies and forces that led to the camps' creation.

Minē Okubo (1912-), an artist whose range goes far beyond her experiences as a concentration camp inmate, received her training at the University of California and was greatly influenced by Diego Rivera's San Francisco murals. In 1942, because of their ancestry, she and her brother were taken to the Tanforan Race Track in San Bruno, where they remained for six months. While incarcerated, she executed an extensive series of charcoal drawings and paintings concerning the evacuation. These haunting works record the hopelessness and dejection of the internees. They reveal both the emotional and physical hardships of life under confinement.

*Minē Okubo
(1912-)*

At the end of the War, Okubo published two hundred of her illustrations in a book entitled *Citizen 13660,* her identifying numbers during incarceration. It was published by Columbia University Press in 1946; West Coast publishers were reluctant to handle such delicate subject matter. The illustrations detail the entire disgraceful relocation procedure as she experienced it. On assembling at a Berkeley church, Okubo was given a specific departure date and was informed that she had three days to wind up her affairs. After hectic packing and other interminable details, she and her brother were finally ready to leave, acutely conscious of the uncertainty of their fate. Immediately prior to their forced departure, they took a final look at their home in Berkeley, a moment recaptured later in a drawing (figure 3-36). The tears on the young woman's cheek tell the story far more effectively than could any dispassionate historical account. The wrenching memory of the final look at one's home inevitably lingers in one's consciousness for a lifetime.

Dehumanization began immediately upon arrival at Tanforan. A *Citizen 13660* drawing depicts the exhaustive search for contraband (figure 3-37) performed on the evacuees. Ostensibly a measure to ensure security, the more important function of the admission search was to impress upon the prisoners a sense of humiliation and subservience. In full view, the men must submit to the embarrassing physical procedure and their expressions mirror their anguished resignation.

Okubo's eventual destination, reached only after a hellish railroad trip, was the internment camp in Topaz, Utah. One of Okubo's drawings provides both a perceptive view of the journey and a broader vision of the moral impropriety of the entire evacuation policy (figure 3-38). The train is stopped in a desolate region of Nevada to allow the prisoners to get out and stretch. What is significant, however, is not the decency of this convenience but rather the context in which it was permitted. Barbed wire surrounds the train on both sides of the tracks. Two soldiers, ominously armed with large rifles,

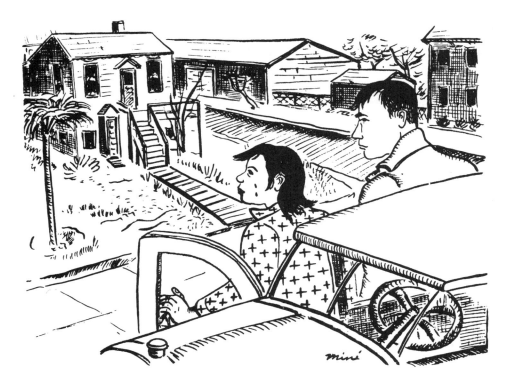

Fig. 3-36. Miné Okubo, "Goodbye to Berkeley and our Home."

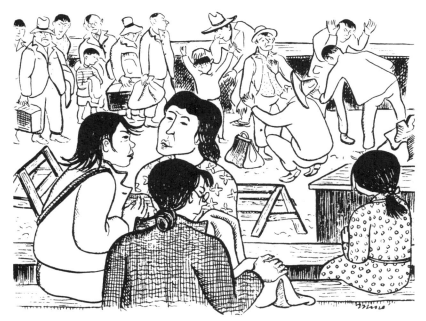

Fig. 3-37. Miné Okubo, "On our arrival in camp we were searched for contraband."

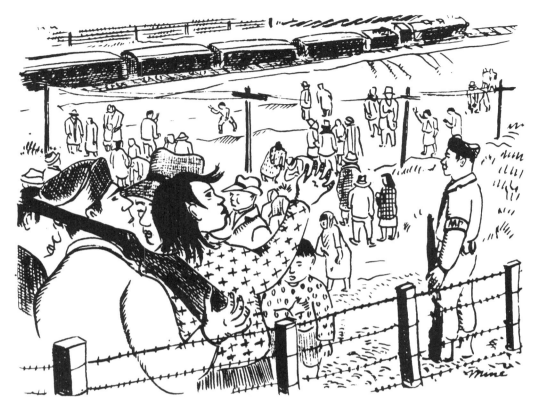

Fig. 3-38. Miné Okubo, "On our long train trip from California to Utah we were allowed to stretch our legs in the desert in Nevada with soldiers on guard."

dominate the picture's foreground. These procedures inevitably exacerbate the pervasive emotional tensions of the journey; here, as in the camps, the Japanese must experience incomprehensible shame and guilt, for not a single passenger had ever been convicted of a criminal offense. That their "relocation" was blatantly unconstitutional is now widely recognized, and a further value of the drawing lies in its ability to shift public attention from legal abstraction to vivid, concrete reality.

The traumatic impact of World War II and its aftermath and the rise of new, nonsocial modes of artistic expression shortly eclipsed the dominance of social art in U.S. cultural life. All forms of creative endeavor are of course affected deeply by the impact of history and politics. The triumph of socially conscious art during the 1930s was conditioned by the severe and debilitating events of the Great Depression. Although the United States has yet to experience any single event as devastating in ensuing decades, malaise of many kinds, not just economic, would be impetus for the vigorous continuation of socially critical artistic endeavors.

.

In the 1940s, the first American style to have a major impact on the art world emerged. Abstract Expressionism, given impetus by prosperity in the aftermath of World War II, dominated the U.S. art scene for the next two decades. Jackson Pollock, Adolph Gottlieb, Franz Kline, Willem De Kooning, Mark Rothko, Hans Hofmann and others became some of the most influential artists working in the United States. These artists, who differed substantially in personal style and temperament, generally sought to express the intensity of human experience in abstract, nonobjective forms. They used paint in unorthodox ways, attempting to explore new "realities" through immediate sensation and spontaneity; they tried to capture subjective, psychological truths. In contrast to socially conscious art, Abstract Expressionism is generally nonrepresentational and does not purport to evaluate topics of political and social controversy.

Despite the historical importance of Abstract Expressionism and its contribution to the nation's cultural vitality, there have been many post-War U.S. artists who have opted not to work in that style. These men and women have continued the tradition of social criticism by producing artistic content directly confronting the myriad forces of political misconduct and social injustice. Representing a wide diversity of artistic approaches and personal ideologies, all share a profoundly critical view of U.S. life in the second half of the 20th century.

Although it would be impossible to identify all of the contemporary artists who fall within the broad definition of the art of social conscience, some, like Jack Levine, George Tooker, and Leonard Baskin, are internationally known figures. Others are known more modestly, and some are known only in their communities or circle of friends and colleagues; fame, of course, is sometimes arbitrary. In any case, the purpose here is to provide a reasonable survey of the diverse array of recent U.S. socially conscious art.

The most appropriate point of departure for a consideration of the descendents of U.S. Social Realism lies in the work of Jack Levine (1915-). Often associated directly with such artists as Shahn, Gropper, and Evergood, Levine is actually quite a bit younger than his distinguished colleagues. Born in Boston of Jewish immigrant parents, he grew up during the Depression partly on the South End tenement streets. He studied at the Boston Museum School, and was greatly influenced by Rembrandt and Daumier, as well as by contemporary Europeans. Extremely idealistic, he was constantly distressed by his perceptions of U.S. life, and his work has treated such themes as the miscarriage of justice, the greed and insensitivity of the rich, the crookedness and hypocrisy of U.S. politics, and such topical issues as Spanish

CHAPTER 4
THE HEIRS OF SOCIAL REALISM

Jack Levine (1915-)

fascism, U.S. policy in Viet Nam, and the struggle for civil rights by black Americans.

Levine has consistently employed visual distortion ("a dignified way of saying caricature") to communicate his outraged view of social reality. Like George Grosz, Levine has consciously created a set of stereotypes that serve as the objects of his critical scrutiny. Levine's objectives are intentionally rhetorical; he seeks to alert his audience to the dangers he exposes.

Levine is associated with the original Social Realists by virtue of some brilliant early works of the 1930s. A 1937 painting, "The Feast of Pure Reason," portrayed the insidiously close relation between political influence and economic power. The painting's excellence early established Levine as one of the country's most promising artist-satirists.

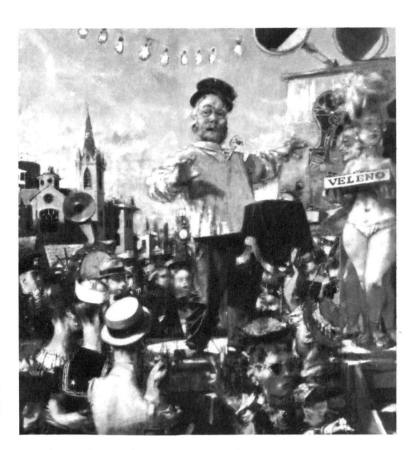

Fig. 4-1. Jack Levine, "Medicine Show," The Metropolitan Museum of Art, gift of Hugo Kastor.

A consistent feature of Levine's art is an understanding of the follies that characterize human experience. An excellent example is "Medicine Show" (figure 4-1), painted during 1955 and 1956. It portrays a hawker who has a quick and magical cure for virtually any ailment. The hawker's confident manner is bolstered by the traditional resort to sex to sell products in the U.S. The near nudity of the women at the

right underscores the sordid character of the entire enterprise. And the hawker's expression reveals the endeavor's shadiness as well. Inclusion of the word "VELENO," Italian for poison, tells us all we need to know about the bogus potion. Here, Levine has captured that sometime human propensity to seek simple solutions to complex problems.

Levine, like many artists and writers whose works were stigmatized during the Cold War, vigorously opposed the McCarthy era's hysteria. Loyalty investigations, abuses of constitutional guarantees of civil liberties, and malicious assaults on the character of innocent citizens made the period a sorry chapter in U.S. history. "Witches Sabbath" (figure 4-2) is a bitter view of these congressional witch hunts. The Ku Klux Klan regalia in the background sets the tone, especially in light of the witches sabbaths in European history. In

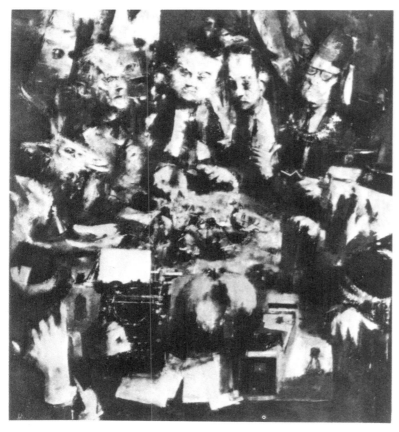

Fig. 4-2. Jack Levine, "Witches Sabbath," courtesy of the artist.

the center is Senator Joseph McCarthy himself, and to the right is his unsavory cohort, Roy Cohn. The typewriter belongs to an uncritical reporter—fooled by the fraudulent "evidence" on McCarthy's table—and alludes to the press role in creating an equally uncritical public. Visual distortion here emphasizes the murky nature of the proceedings.

The civil rights movement of the early 1960s had a pro-

found effect upon Levine. He sympathized with black Americans' struggle for justice and equal opportunity, and was horrified by the brutal repression of civil rights demonstrators. One of the worst incidents occurred during 1963 in Birmingham, Alabama. One of the most segregated cities in the United States, Birmingham was the target of a series of sit-in demonstrations led by Dr. Martin Luther King. Demanding an end to racial discrimination in public facilities, King, his associates and hundreds of followers were repeatedly arrested and assaulted by public authorities. The use of fire hoses, armed cars, and dogs by the police made Birmingham a symbol of racism throughout the nation and the world. The media reported from Birmingham daily, with special emphasis on the widespread instances of police brutality. Levine responded with one of the finest protest paintings in recent art history. "Birmingham 1963" (figure 4-3) highlights the bravery of the civil rights demonstrators in the face of violent opposition. In a blurred nightmarish composition, police dogs are accentuated, testifying to the brutality with which the old order is upheld; the calm dignity of the dedicated marchers is impressive by contrast. Levine's brushstroke and use of white points of light suggest the charged and tense atmosphere of the civil rights struggle.

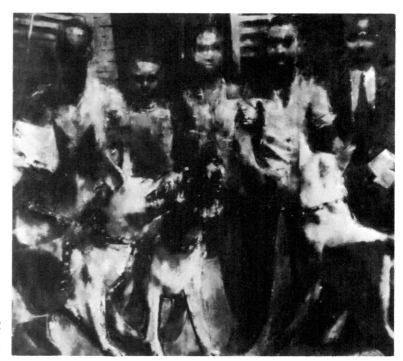

Fig. 4-3. Jack Levine, "Birmingham 1963," courtesy of the artist.

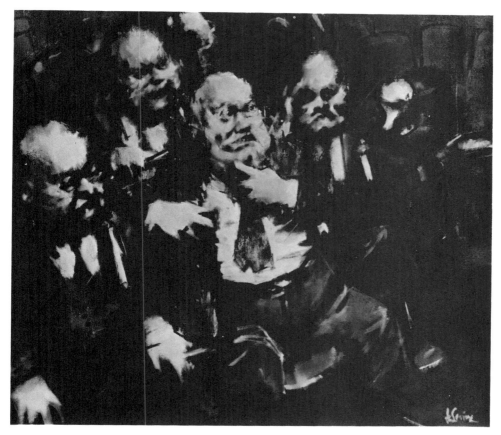

Fig. 4-4. Jack Levine, "Daley's Gesture," Kennedy Galleries, New York.

Levine was present at the 1968 Democratic Party Convention in Chicago, another recent site of massive violence. Some of his sketches there depicted the boredom of convention delegates, while others chronicled the brutal police response to Vietnam war protestors. Levine also focused on the figure of Chicago's Mayor Daley. The major work of art to emerge from the Chicago convention, "Daley's Gesture" (figure 4-4), is a savage view of a recent political boss. The mayor's distasteful action was promoted by a speech of Connecticut Senator Abraham Ribicoff. Castigating the mayor and his administration for complicity in the bloody street violence occurring outside the convention, Senator Ribicoff eloquently appealed for rationality and morality. Daley's obscene gesture during that appeal is indicative of the moral and political corruption of the Chicago machine.

Jack Levine's body of work marks him as the most prominent descendent of the Social Realist tradition of the 1930s. Now in his 60s, Levine will surely continue to provide works of art that combine technical excellence with deep commitment to conscience.

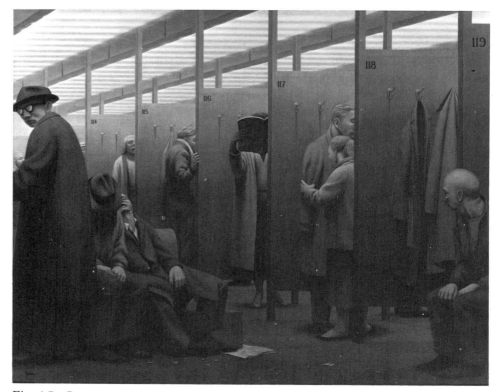

Fig. 4-5. George Tooker, "The Waiting Room," National Collection of Fine Arts.

George Tooker
(1920-)

George Tooker (1920-) is unique among artists. None are even remotely similar stylistically or in the nature of their vision. He is clearly the most interesting heir to the Magic Realists, although that categorization is not entirely adequate. Tooker's art is a cumulative picture of a society both hostile and indifferent, and one devoid of meaningful human communication. His carefully conceived and executed works reveal modern urban life's relentless devouring of individuality and personality. His paintings especially reflect the dehumanizing tendencies of such advanced industrialist-bureaucratic societies as our own.

The social content of Tooker's art is universally apprehensible and meaningful for the individual, who likely has experienced the realities the artist portrays. "The Waiting Room" (figure 4-5) is an extraordinary glimpse of human isolation. Hiding from one another, the men and women seem compelled to stay within their cubicles. Their vacant stares reveal the omnipresent lack of personal autonomy, while the furtive expressions of some suggest an amorphous but powerful feeling of guilt. The woman in the center, whose face is virtually replaced by the cover of a slick covered with the mask of a magazine, symbolizes the total absence of human identity; and it may be only for the dubious and fleeting

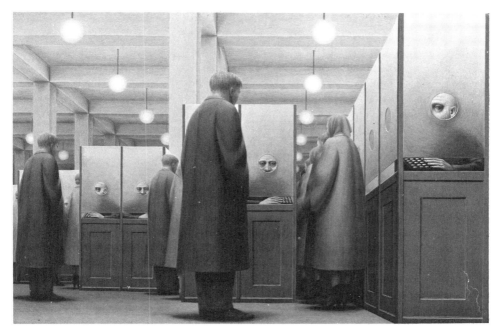

Fig. 4-6. George Tooker, "Government Bureau," The Metropolitan Museum of Art, George A. Hearn Fund.

opportunity to be like her that those on the left wait. Highly reminiscent of Luis Buñuel's film *The Exterminating Angel,* the message of the painting emerges dramatically: the myriad forces of social life relegate individuals to an unending pattern of waiting for fulfillment that tragically never comes.

Tooker's treatment of the world of bureaucracy is unparalleled. His maddening experiences with petty officials and frustrating regulations—he once spent weeks in Brooklyn's Borough Hall attempting to obtain a building permit—prompted Tooker to paint the famous "Government Bureau" (figure 4-6). The work metaphorically depicts experiences repeated millions of times daily. The painting's most striking feature is the total absence of personal responsiblity. Nobody behind the pointedly frosted windows of the agency is identified; no face is wholly visible and features are not individualized. The sallow-faced creatures behind the windows are "only following instructions and enforcing the rules," reinforcing the impression that no one in a bureaucracy is responsible.

The artist also forces the viewer to consider the role of the victims. Like many people confronted by an assault on identity, they accept the path of least resistance, adapting to bureaucratic idiocies. In "Government Bureau" Tooker portrays this situation of dispassionate collaboration with alienation.

"Ward" (figure 4-7) adds another dimension to Tooker's vision. Once again, excruciating isolation dominates the scene. Each individual exists alone, without extrapersonal communication. The inmates' close proximity, within a grid that might be endless, only makes their alienation more painful. "Ward" is a critical view of all dehumanizing institutions; like most of Tooker's compositions, the purposely indistinct figures and environment are generalizable to society at large. Thus Tooker's focus is on the social origins of widespread individual anxiety. Exemplary is the elderly woman at the right, cast adrift by a society that perceives the elderly as marginal—so much so that in "Ward" the woman, visage cropped, remains only partly in the picture. And Tooker's depiction in the background of the U.S. flag makes it clear that it is particularly our society's fetishistic concern for "youthful vitality" for which this work's message is intended.

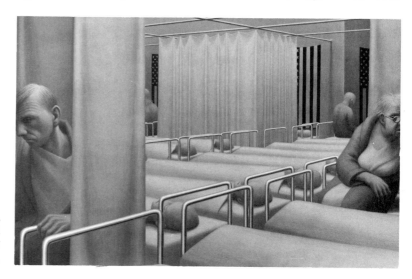

Fig. 4-7. George Tooker, "Ward," Frank Rehm Gallery, photo by Geoffrey Clements.

Leonard Baskin (1922-) Moral Realism

Leonard Baskin (1922-) has devoted his entire career to his own humanistic, social, and ethical philosophy. Like his late friend, Ben Shahn, Baskin is a serious intellectual whose art is underpinned with a complex theoretical foundation. His writings reveal a vigorous opposition to the avant-garde in art because of his commitment to figurative content. Baskin's dedication to what he calls "moral realism" has impelled him to depict harsh truths about the human condition. He writes:

> Man has always created the human figure in his own image, and in our time that image is despoiled and debauched....Man has been incapable of love, wanting in charity and despairing of hope. He has...charred the earth and befouled the heavens more wantonly than ever before. He has made of

Arden a landscape of death. In this garden I dwell, and in limning the horror, the degradation and the filth, I hold the cracked mirror up to man.*

For Baskin, "it is the special province of the Graphic Arts to be tendentious, to excoriate, attack and denounce..."**

Baskin has confronted the vast complex of life-negating forces that dominate modern existence—war, persecution, personal alienation, the threat of nuclear catastrophe, and environmental breakdown. His work's haunting darkness is reminiscent of Käthe Kollwitz and Edvard Munch. Baskin's art joins a personal symbolism with the more familiar social protest forms used earlier by Social Realists.

Baskin's primary reputation rests with his work as a sculptor and as a graphic artist. As a young man, immediately after World War II, he formulated a socialist position, which he sought to incorporate into his sculpture. He found, however, that the results were neither effective nor satisfying. Because he was not content to omit social and political subjects from his work, he turned to graphic art, which he thought was more naturally suited for the presentation of his social ideology. He viewed the print as the best medium through which to communicate a message publicly. In his own writings, Baskin acknowledges his debt to the great social printmakers who preceded him.

Among his graphics is a series of twelve gigantic works, which the artist describes as the capital achievements of his graphic career. Each is monumental in conception and execution. There are two, however, that are unusually appropriate to the theme of social conscience.

Leonard Baskin responded to the McCarthy era with dramatic indignation. In 1952 he executed a large woodcut entitled "Man of Peace" (figure 4-8). The figure, five feet tall, is restrained behind barbed wire, accentuating the political climate of McCarthyism. The man's facial expression clearly reveals his sorrow and pain. The injured dove further illustrates the pernicious consequences of political persecution. There is, however, a note of hope in the woodcut. In the barbed wire are flowering plants as well as thorns. The plants are far from vibrant, but they remain nevertheless as a possibility of human resiliency and transcendence.

Like Shahn, Baskin is horrified by the possibility of atomic warfare. In 1954 he executed another of his gigantic

*Leonard Baskin, *Baskin: Sculptures, Drawings, and Prints* (New York: Braziller, 1970), p. 15.
**From Baskin's acceptance speech at the time of the award of the Gold Medal for Graphic Art, presented by the National Institute of Arts and Letters.

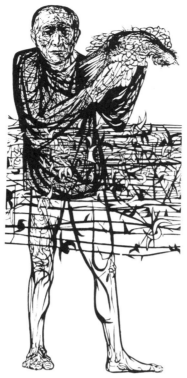

Fig. 4-8. Leonard Baskin, "Man of Peace."

Fig. 4-9. Leonard Baskin, "Hydrogen Man," Kennedy Galleries, New York.

woodcuts of social conscience. "Hydrogen Man" (figure 4-9) is stark and apocalyptic in its warning to all humanity. The skin of the flayed figure is decomposing, a dark portent for the future if people refuse to abstain from martial endeavors. Baskin has recently executed additional prints of this woodcut in blood red.

"The Hanged Man" (figure 4-10), another Baskin print, summarizes the human condition in the modern era. Intentionally general, the disembowelled and bloodstained hanging victim represents the millions who have perished in a century that has spawned Auschwitz, Hiroshima, and Vietnam as well as scores of lesser known examples of barbarism and genocide. This powerful woodcut compels the viewer to contemplate the enormous gap between social ideals and actual human performance.

Baskin has not neglected topical themes. One recent series of drawings ridicules the arrogant and violent sheriffs who symbolized opposition to the struggles for racial justice during the 1960s. Like Jack Levine and Ben Shahn, Baskin contributed artwork to the New York exhibition "Protest and Hope," as a gesture of opposition to the war in Vietnam. The

Fig. 4-10. Leonard Baskin, "Hanged Man," Kennedy Galleries.

Fig. 4-11. Leonard Baskin, "Our General."

artist's repugnance for this war finds expression in an ascerbic view of a U.S. general, an ink drawing entitled "Our General" (figure 4-11). The absurdity of the general's face and the pomposity of his decorations portray an odious and dangerous military mentality. The iron cross covering the General's crotch highlights the special immorality, stupidity, and irrationality of the American adventure in Southeast Asia, and its placement alludes to the war's possible psychosexual sources.

Jack Levine, George Tooker, and Leonard Baskin are clearly the most important descendants of the Social Realist spirit of the 1930s. However, many other contemporary figures add to the vitality of the socially conscious tradition in the visual arts. One of the most interesting representatives is Charles Bragg (1931-), who has recently begun to attract substantial critical attention for his satirical imagination. A painter and an etcher, he has displayed an uncanny ability to attack the hypocrisy of facets of contemporary American life. His works are simultaneously uproariously funny and profoundly serious.

One of the major themes in Bragg's art involves a sardonic view of the army and of military institutions in the

Charles Bragg (1931-)
Painter & etcher

United States. Bragg has isolated several objects for satirical scrutiny: draft boards, high-ranking military officials, army recruiters, and political leaders with military backgrounds. He views them as advocates of a narrow nationalism responsible for promoting international tension and internal strife and suggests, often without subtlety, that their bellicose attitudes are closely related to fears about their own masculinity. "The Big Gun" and "The Medal" (figures 4-12 and 4-13) focus exclusively on the artist's view that the wielding of guns and warfare may be attempts by misguided men to assure themselves of their own virility.

Another favorite topic of Bragg's is the pretensions of various professions. His etchings are visual counterparts to George Bernard Shaw's remark that all professions are conspiracies against the laity. No group is left unscathed: doctors, scientific researchers, dentists, and especially lawyers. Bragg shows with devastating accuracy lawyers' manipulation of their clients and the courts, and portrays judges as pompous or stupid political hacks who lack genuine dedication to principles of justice. Similarly, he depicts most jury members as unimaginative, ignorant, and uneducated fools.

His treatment of the medical profession is equally impressive and sardonic. Focusing on such specialties as anesthesiology, plastic surgery, and gynecology, Bragg has combined biting humor with intellectual acuity. His treatments of American gynecologists are especially powerful revelations of the sometimes insensitive and sexist nature of gynecological practice. Such sexism, abundant in the American patriarchy, is particularly apparent in the gynecologist's treatment of his patient as "just another body," a view that disregards special physical and psychological considerations her gender may pose. As a recent Department of Health, Education, and Welfare study noted, many doctors, enthusiasts of Caeserean section delivery,

> talk as if there were something wrong with women who want to have their babies the old-fashioned way... Obstetricians repeatedly asked: 'What's so great about delivering from below (vaginally) anyway?' "*

Both Bragg etchings shown here are entitled "The Gynecologist" (figures 4-14 and 4-15). The physician on the left is merely a sleazy practitioner. Employing detail masterfully, Bragg depicts the doctor, with his Playboy tie-pin and standing in front of a chain-locked examining room door, as the epitome of lasciviousness. The doctor on the right, peering lustfully, violates the patient's trust in what is an inherently

*Mother Jones, July 1980, Volume V, No. VI, p. 31.

private and delicate procedure. Both etchings raise large issues concerning professionalism, for through their mystification of knowledge, the professions create and maintain networks of dependence not just in the doctor's office, but in all our social and political institutions. In a capitalist-professional society, of course, dollars and status are earned through such mystification, the end product of which may be the dependent party's alienation and mistrust.

One of the features of Bragg's recent work is relentless criticism of religion. Sometimes gentle, sometimes brutal, Bragg continues the long tradition of such masters as Hieronymous Bosch, Brueghel, and Goya.

Bragg's satirical illustrations of Genesis expound this anticlerical and antireligious theme. One of his funniest parodies is entitled "In the Beginning There Were Mistakes" (figure 4-16). A gentle rebuke of those who adhere to a literal interpretation of Genesis, the work depicts a stereotypical God sadly contemplating erroneous attempts to create heaven and earth. Significantly, this work has appeared during a period of revived interest in fundamentalist religion. Now, when many would replace Darwin with divine creation in the textbooks, Bragg's efforts are a welcome return to wit and rationality.

A more savage view of religion is found in the allegorical "Procession" (figure 4-17). The work denounces the complicity of organized religion with a vast array of historical atrocities. The etching is dominated by a Pope-like figure who is surrounded by religious "campfollowers." The repulsive "Pope" wears a shark's head hat and a mask, presenting a different image to the divine audience above and to the worldly one at his feet. To his left are the corpses of two hanged men, presumably victims of violent religious fanaticism. At the top right portion of the composition, invoking tragic images of the conflict in Vietman, a hooded, Klannish cleric in conjunction with a crazed general leads Asian victims to inexorable doom. The work as whole openly questions the moral validity and notes the potential dangerousness of organized religion.

Of Italian descent, Antonio Frasconi (1919-) was born in Argentina and has become one of America's finest woodcut artists. Artistically inclined and politically engaged since his early youth, he has maintained a commitment to a moral vision in art throughout his career, arguing eloquently that an artist must remain part of the world, sharing and expressing both life's joy and its sorrow. He is committed, too, to the idea that it is the artist's responsibility to search out misery and injustice, to exposing it to as many as possible; this exposure, he believes, will in time encourage people to overcome oppression and exploitation.

*Antonio Frasconi
(1919-)*

Fig. 4-12. Charles Bragg, "The Medal," courtesy of the artist.

Fig. 4-13. Charles Bragg, "The Big Gun," courtesy of the artist.

Fig. 4-14. Charles Bragg, "The Gynecologist," courtesy of the artist.

Fig. 4-15. Charles Bragg, "The Gynecologist,"
courtesy of the artist.

Fig. 4-16. Charles Bragg,
"In the Beginning There
Were Mistakes," courtesy
of the artist.

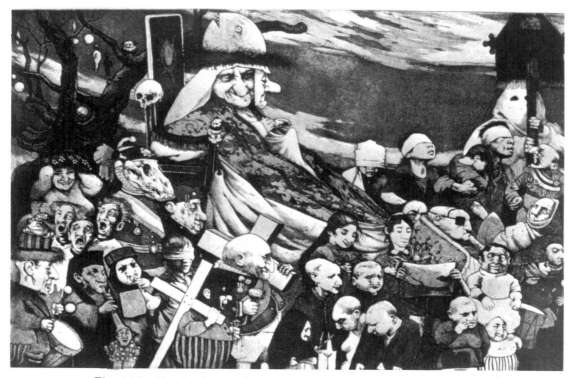

Fig. 4-17. Charles Bragg, "The Procession," courtesy of the artist.

Frasconi's family moved to Montevideo, Uruguay, when he was an infant, where the artist lived until coming to the U.S. in 1945. The Spanish Civil War mobilized him as it did other artists and intellectuals to employ his art on behalf of causes and principles he believed were just. Like the Vietnam War in the 1960s, the Spanish conflict engendered powerful passions that could last a lifetime; for Frasconi, it catalyzed the subsequent social content of his art.

Frasconi's arrival in the U.S. in 1945 coincided with the onset of the Cold War and the repressive politics that developed in its wake. Carrying on the work he had begun in his native South America, he used his art to express his indignant response to these current political events, as well as to such past infamous occurrences as the case of Sacco and Vanzetti.

Frasconi's activities as a book illustrator add to his stature. Illustrating the works of such major literary figures as Herman Melville, Federico Garcia Lorca, Bertolt Brecht, and Pablo Neruda, his graphics add a magnificent visual dimension to the literature. Typical is a woodcut, done for Brecht's "Song of a Stormtrooper," which chillingly portrays

the mindless German SS and their monstrous instruments of death and destruction.

More recently, reacting to the atrocities of U.S. involvement in Vietnam, Frasconi created a portfolio of protest prints. Each work in the series is masterful. Typical is one (figure 4-18) that combines woodcut with photoengraving. On the left is the instrument of destruction, identified by its insignia as a U.S. bomber and flown by men who rarely saw the grisly results of their impersonal and technologically efficient saturation bombing. To the right are the inevitable human "results." Like Baskin, Frasconi makes the human connection in his portrayal of the relentless patterns of tragedy and death. Frasconi's work stands both as a memorial to the thousands of Vietnamese who perished, and as a protest against U.S. imperialism.

In the spring of 1970, the Nixon administration extended the Vietnam War into neighboring Cambodia. Thousands of people responded with unanticipated anger in a series of protest demonstrations that rocked the country. The campuses of U.S. colleges and universities were especially active as centers of antiwar protest activity, which became increasingly violent. Student disorders were met with overpowering opposition from police and even military units. The worst incident occurred at Ohio's Kent State University. During a series of student demonstrations, the Ohio national Guard was called to the campus, ostensibly to maintain order. What occurred, however, would soon shock the nation and the world, for during one of the campus melees, soldiers from the Guard unit fired into a crowd of students. Four young men and women were killed, as the greater destruction abroad called for greater repression at home.

Frasconi's "Law and Order—Kent" (figure 4-19) is one of the most powerful political works of the artist's career, plainly condemning domestic military brutality. Frasconi superimposes an ominous target on the center of a composition that depicts the fallen students from four gruesome angles. The work was one of several prints emphasizing the dangerousness of the then-dominant "law and order" U.S. political leaders. Companion prints treated the tragic events in Attica Prison, Wounded Knee, and San Quentin Prison, where black convict George Jackson was killed in an alleged escape attempt. The series reaffirmed Frasconi in the front ranks of socially engaged art.

Ralph Fasanella (1914-), a so-called "primitive" painter who has created a unique style without formal training, is a recent "discovery." Few knew of him until he was fifty-eight years old and was, as usual, working in a New York gas station. Since then, his politically and historically vital work has been displayed in a one-man show, and he has

*Ralph Fasanella
(1914-)*

Fig. 4-18. Antonio Frasconi, "Vietnam," by permission of Macmillan Publishing Co., Inc.

Fig. 4-19. Antonio Frasconi, "Law and Order—Kent," permission of MacMillan
Publishing Co., Inc.

been the subject of both a *New York Magazine* cover story and an excellent book, *Fasanella's City*.

Fasanella's roots and personal life are deeply embedded in the working class. That experience has been the source and focus of his art, which has been an avocation to Fasanella's full-time work as a laborer. His proletarian origins led him to union involvement, and he became a labor radical, a perspective apparent in his art.

One of Fasanella's themes is New York City, to him both fascinating and hard-edged, the quintessential American city. Capturing the crowded, teeming character of the metropolis in meticulous detail, Fasanella provides a cross section of city life and all its aspects, including neighborhood baseball games, schools, and ethnic street fairs. His paintings are passionate critiques of Park Avenue's affluent minority and sympathetic portrayals of the tenement-dwelling majority, of May Day as a socialist holiday, and of union organizing.

Fasanella was also moved to commemorate Vito Marcantonio, once a protege of Mayor Fiorello LaGuardia and for years the most radical member of the U.S. House of Representatives. Marcantonio had also served as head of the American Labor Party in New York, probably the last organization in U.S. history to help radical politics significantly affect the electoral process. Fasanella was deeply impressed by Marcantonio, a socialist politician in touch with his working-class constituents and a man whose dedication to honesty and ideological principle was widely acknowledged. "Death of a Leader" (figure 4-20), painted the year of Marcantonio's death in 1954, is a moving tribute to a man who meant so much to thousands of people and on whose behalf Fasanella had worked. The painting's setting is the streets of New York. The body of the leader, dead from a heart attack, lies in an open casket. The work's most striking feature is the long lines of grieving mourners; the presence of Blacks and Puerto Ricans signifies the esteem for Marcantonio held by New York's large minority communities. Beloved by the people, Marcantonio was a rarity in U.S. political life. Fasanella's "naive" style and customarily brilliant color intensify the viewers' response to what is obviously the artist's heartfelt grief and respect.

Fasanella's most impressive political paintings expressed his horrified reactions to the trial and execution of Julius and Ethel Rosenberg during the anticommunist hysteria of the Cold War. The early 1950s were marked by considerable furor regarding atomic spying. The United States-Soviet Union rivalry for nuclear supremacy spawned mutual mistrust and domestic tension. The Rosenbergs, members of the Communist Party—USA, were arrested and accused of passing atomic secrets to the U.S.S.R. Convicted and sentenced to

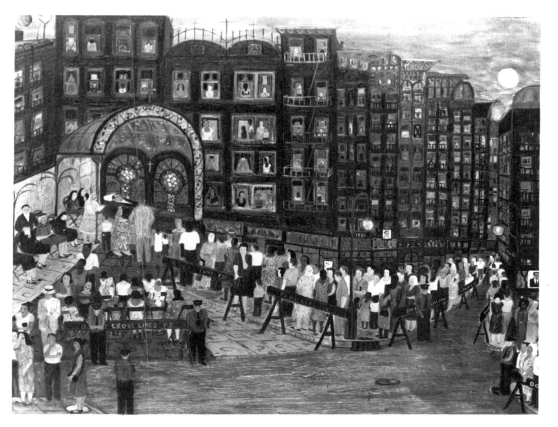

Fig. 4-20. Ralph Fasanella, "Death of a Leader," permission of Alfred A. Knopf, Inc.

death, the Rosenbergs embarked on years of fruitless appeals that went as high as the Supreme Court; finally, after President Eisenhower's denial of commutation, the couple was electrocuted in Sing Sing Prison in June 1953.

Fasanella was involved in protest and other activities on behalf of the Rosenbergs. His feelings remained strong for a decade after the execution, demanding expression in art. In 1963 he finished the masterwork "Gray Day" (figure 4-21). The large letter "A" in the center stands for "atom," symbol of the entire controversy. At the lower right are protest demonstrators who braved the wrath of their neighbors by publicly opposing the anticommunist hysteria of the times. At the lower left and near factory workers above are people from the Save the Rosenbergs Committee. Hoping desperately for an eleventh-hour commutation or stay of execution, they are destined to frustration.

Beneath the central "A," Julius and Ethel Rosenberg sit in their death cells alone, but near other anonymous victims of political persecution in the U.S. Directly above, Julius and

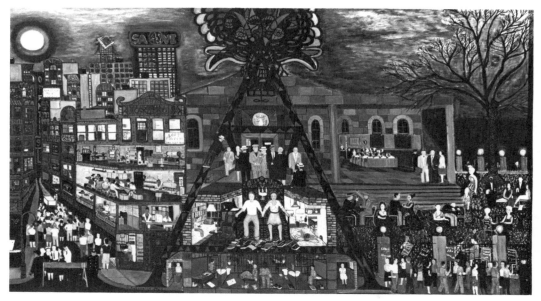

Fig. 4-21. Ralph Fasanella, "Gray Day," permission of Alfred A. Knopf, Inc.

Ethel Rosenberg appear again. This time, in keeping with Fasanella's tendency to combine disparate spaces and times, they sit in their own living room, in seats strongly reminiscent of the notorious electric chair. Their small orphaned sons sit on each side, poignant reminders of the personal tragedy of the Rosenberg case. Rows of books surround the couple, an expression of the view that the Rosenbergs died because of their left wing ideas, not because they were guilty of atomic espionage.

At the top of the "A," directly above the Rosenbergs' living room, prosecutors and other prominent persons congratulate themselves on the death sentence. Finally, a gray sky hovers over the entire scene, an ominous warning, and now a reminder, of the perilous political climate of the Cold War.

Fritz Scholder (1937-)

The work of Fritz Scholder (1937-), another heir of the Social Realist tradition, topples the public's stereotypes of Native Americans and informs the viewer of the difficult conditions now facing that ethnic group. Scholder is part of the new Native American political consciousness, one which was evidenced dramatically for the public by recent events at Alcatraz and Wounded Knee. Part Native American himself, Scholder hopes that his dynamic paintings and lithographs will make the majority population aware of Native Americans' contributions to this country and instill respectfulness of their customs.

Historically, Native Americans have been targets of genocide and repression, and have endured the legally-sanctioned expropriation of their lands. In the 1823 landmark case of *Johnson v. M'Intosh*, the United States Supreme Court held that any transference of land by a Native American was void; as a "conquered race," Native Americans were no longer capable of landownership. Today, court battles still rage as dispossessed Native American tribes seek recompense for their losses.

The popular media and visual arts have long perpetuated ill-conceived Native American stereotypes. One distortion has been that of the "Noble Savage," an idealized and romanticized view that belittles tragic historical realities; another has been that of the scalping, bloodthirsty "Injun," while yet another has been that of the degenerate drunk.

Scholder has chronicled the difficult Native American search for an identity that this racist legacy has obscured. "Super Indian No. 2" (figure 4-22) is a vivid portrayal of the ambiguities of this superhuman search and the dilemmas that Indians must face daily. The dominant society has simultaneously broken most of the indigenous patterns of Native American culture and prevented serious attempts at assimilation. In the painting, the headdress symbolizes old traditions while U.S. culture is represented by a double-dip strawberry ice cream cone. Caught in the middle, it is difficult for the Native American to forge an autonomous definition of his own existence, the first step in his resistance to an oppressive order.

The poverty of reservation life, exacerbated by official and public indifference, has also generated widespread personal torment among Native Americans. Like most socially conscious artists, Scholder identifies these problems by focusing upon their personal consequences. "Screaming Indian No. 2" (figure 4-23) is a wrenching depiction of a tortured life. Francis Bacon's influence here is obvious, as the distorted facial expression of the Native American, degraded and beaten to the brink of insanity, mirrors the historical assault on his culture, his traditions, and his personal existence.

Among the most powerful of themes in the art of Fritz Scholder is his treatment of the ever-present specter of alcoholism. The 1970 painting, "Indian in Gallup" (figure 4-24), highlights a Native American derelict, and is hardly a simplistic treatment of the stereotype. Clearly this "un-Noble Savage" is a casualty of the cumulative pressures of poverty, alienation, and discrimination. Yet Scholder is not reluctant to offer a critical view of his fellow Native Americans. The degradation of the Native American in the painting is at least partially due to his own lack of personal responsibility, albeit

Fig. 4-22. Fritz Scholder, "Super Indian #2," Solomon Schecter Day School, New York.

Fig. 4-23. Fritz Scholder,
"Screaming Indian #2," courtesy
Mrs. Marietta Scurry Ransome,
Dallas, Texas.

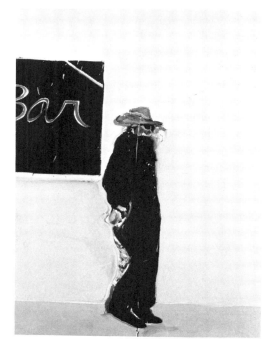

Fig. 4-24. Fritz Scholder,
"Indian in Gallup," National
Collection of Fine Arts.

Peter Saul

government bureaucracies have helped foster dependence. In critiquing the broader patterns of U.S. social life, Scholder's critique is matched by his concern with defects of contemporary Native American life.

San Francisco Bay Area artist Peter Saul's style of painting is entirely unique. Using paint and pencil to produce a cartoon effect, he comments upon a wide diversity of social topics, including the corporate state, the oppression of minority groups, poverty, and the war in Vietnam. His works are satirical, presented with a vulgarity calculated to offend the viewer. On one level, his perceptions are simplistic, verging on a conspiratorial view of U.S. economic and political relationships that is emotionally appealing, though rarely intellectually precise. But on another level, such exaggeration, especially when presented in vivid, brutally unsubtle artistic form, raises issues in powerful ways.

One of Saul's most crudely vulgar works is a vicious sexual parody of Richard Nixon. Entitled "Nixon and Queen Mudder" (figure 4-25), the painting is an obscene portrait of the discredited former president and his wife. The work's bad taste is highlighted by gross distortion of genitalia; labelling accentuates the visual imagery. Nixon as "Mudder Fugger" is a vicious judgment, intensified by the pornographically literal depiction in the painting. Saul clearly believed that the vulgarity of Nixon's Administration justified an equally vulgar artistic response. After all, if the executive couple's acts are

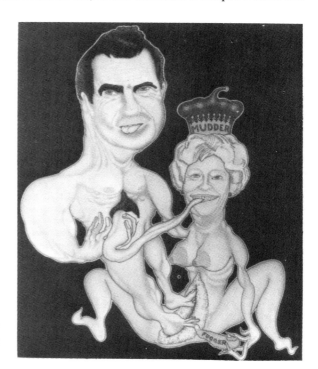

Fig. 4-25. Peter Saul, "Nixon and Queen Mudder."

offensive, they pale in comparison to U.S. bombing in Southeast Asia, illegal spying by the military and Central Intelligence Agency, and Watergate, the cumulative heritage of the Nixon Administration. For Saul, only a thoroughly vulgar and demystifying artistic expression can begin to communicate the utter depravity of the Nixon era. If successful, the work will focus less attention on its pornographic features than on broader political and historical problems.

In the recent history of U.S. socially conscious art, a few individual works are so striking or profound that they deserve mention here. An outstanding example was painted in 1963 by G. Ray Kerciu, then a professor of art at the University of Mississippi. During that year, James Meredith, a Black, sought entry into the University. His efforts were resisted vigorously, as Governor Ross Barnett invoked the full authority of his office in an attempt to preserve the University's segregationist heritage. The Governor's actions brought the State of Mississippi into open conflict with the United States government.

G. Ray Kerciu

Federal efforts prevailed, and Meredith was admitted to his studies, although military protection had to be provided to ensure his safety. Entry of the university's first Black student precipitated massive violence in the town of Oxford, where scores were injured and arrested in one of the ugliest episodes in the history of American race relations. Kerciu was deeply affected by the racism of his fellow Mississippians. His "America the Beautiful, 1963" (figure 4-26) eschewed beauty

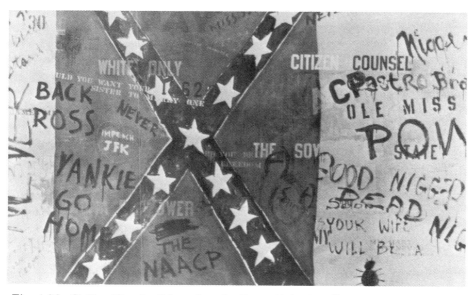

Fig. 4-26. G. Ray Kerciu, "America the Beautiful, 1963," courtesy of the artist.

for grim truth. The artist highlighted a collection of vicious racist sentiments and slogans against the background of a confederate flag. "White Only," "A Good Nigger is a Dead Nigger," and "Would You Want Your Sister to Marry One?" are all evidence of attitudes that have long inhibited the development of humane social relationships in the U.S. The painting focuses attention on the systematic way in which racism has become embedded in our society. As a result of his painting, Kerciu was fired from his university position, another indication of the work's impact. Like Jack Levine's "Birmingham, 1963," "America The Beautiful, 1963" stands as a disconcerting reminder of a past with which we must come to terms.

Ira Nowinski (1942-) Photographer

Ira Nowinski (1942-) is one of the many post-war photographers who grew up in an age when quality cameras were widely available and were relatively familiar to millions of Americans. While the young Nowinski was studying at the San Francisco Art Institute, he became aware of the tragic circumstances endured by the city's large population of elderly poor. They, like thousands of elderly Americans consigned to inner city ghettos, suffered a financial misery exacerbated by isolation. Nowinski was dismayed by the seedy hotels in which they were forced to live and, like the photographer-muckrakers Riis and Hine, decided to chronicle these horrifying circumstances first-hand. Nowinski, determined to evoke the viewer's anguished response, sees such efforts as fundamentally political.

A powerful Nowinski photograph (figure 4-27) shows an old man sitting on a cheap iron bed amidst a tiny, dismal room. Surrounded by his meager possessions, the man passes his time watching television, his sole pleasure in an otherwise empty life. The presence of the flag is tragically ironic, indicating the old man's acceptance of an American dream that has excluded him from its benefits.

Danny Lyons Photographer

Another photographer, Danny Lyons, has documented an unfortunate byproduct of U.S. growth and "progress," the destruction of city neighborhoods. In 1967, a massive urban renewal project, similar to others throughout the nation, necessitated the demolition of sixty acres of buildings in lower Manhattan; the work was done by skilled crews oblivious to the area's architectural heritage and to residents' emotional attachment to their old neighborhood. Lyons' historical record of the desolate buildings, empty rooms, and wreckage of West Street between Jay and Duane (figure 4-28) mirrors urban blight throughout the U.S. Reminiscent of many European cities at the end of World War II, the scene generates uncomfortable, haunting feelings and raises larger social issues at the root of declining urban existence.

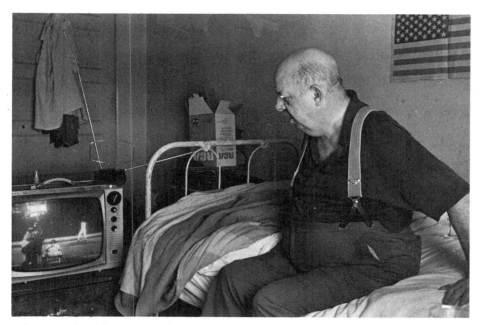

Fig. 4-27. Ira Nowinski, "Old Man Sitting on an Iron Bed,
Watching T.V.," permission of Carolyn Bean Publishers.

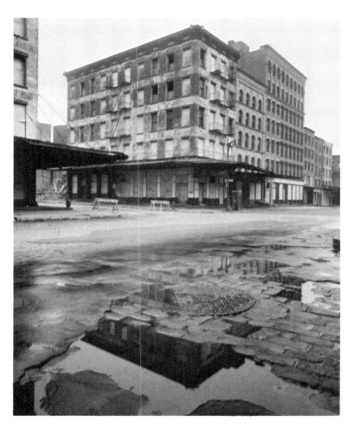

Fig. 4-28. Danny Lyons,
photo from *Destruction of
Lower Manhattan,* courtesy
of the artist.

Fig. 4-29. Ruth Gikow, "Adoration of the Gadget," Kennedy Galleries, N.Y., photo by Geoffrey Clements.

Ruth Gikow

Audrey Preissler

In 1969, Ruth Gikow painted "Adoration of the Gadget" (figure 4-29). The painting sums up the dominant attitudes of millions of Americans who benefitted from the economic prosperity following World War II. A satirical view of mindless consumerism in America, the painting focuses on the manipulation by corporations of human aspirations. Gikow highlights, too, the public's complicity in uncritically accepting whatever gadgets are presented. The work is a warning that so long as millions of Americans are tied to unnecessary materialism, attention is deflected from the social and political defects of modern life, from social obligation and reponsibility. In using her art to posit issues of profound moral concern, Gikow, like the other artists discussed above, fulfills one of the highest objectives of the art of social conscience.

Audrey Preissler, the final artist with whom this chapter will be concerned, is a strikingly modern heir of the Social Realist movement. Working in her studio in Harpers Ferry, West Virginia, she uses her talent to focus on a broad range of social issues. A satirical artist of the highest order, she employs both anger and humor to draw public attention to hypocrisy and insensitivity to human suffering. One of her major emphases is the smugness and callousness of agencies ostensibly created to serve the poor. In a 1974 watercolor, "Commission on Hunger" (figure 4-30), she uses a style she calls personal expressionism to show how official poverty agencies mock the victims of an exploitative society. More basically, the painting calls attention to the all too common tendency to blame the poor for their fate rather than explore the causes of institutional failure. In this and similar efforts, Audrey Preissler reflects the moral and political fervor of the earlier Social Realist tradition.

Fig. 4-30. Audrey Preissler, "Commission on Hunger," courtesy of the artist.

From the 1960s through the present there has been a vast proliferation new and "rediscovered" forms. These media have broadened possibilities of expression for socially committed artists, thus complementing those graphic arts with which this book has heretofore been concerned. This chapter will survey recent developments in the sculptural medium of assemblage; in poster, cartoons, and comic strips; and in murals.

Assemblage

It is important to note that, before the innovation of assemblage, sculpture was rarely directed toward socially committed objectives. It is true that war monuments were sculptured in abundance after both World Wars, but these works, generally banal and ponderous, showed little critical or even partisan awareness. Yet the work of one artist, David Smith, serves as an historical point of departure for consideration of recent social commentary in sculpture.

Smith (1906-1965) developed an early interest in and commitment to Marxism, a viewpoint which made him sensitive to contemporary political events. Horrified by the specter of war and persecution in Europe, in 1938 and 1939 Smith produced a series of fifteen bronze medallions called the "Medals for Dishonor." Each medal was directed against a specific area of sociopolitical misconduct, such as bacterial warfare, the *de facto* exemption of the rich from military service, and the bombing of civilian populations; the medallions were inspired by Greek coins Smith had seen in Athens. In "Propaganda for War" (figure 5-1), he creates an unusual anti-war statement. The classical origins of the series as a whole suggest a universal theme transcending the immediacy of Nazi aggression in Europe. Another work, "Profit," pointedly critiqued the profiteering that encourages the strong to exploit the weak. Cast in 1946, the work employs a predatory bird to symbolize the pernicious consequences of capitalism. The monstrous creature surges forward in a frenzied pursuit of profit and economic domination.

CHAPTER 5
THE 60s & 70s
A PROLI-FERATION OF FORMS

Assemblage Medium

*David Smith
(1906-1965)*

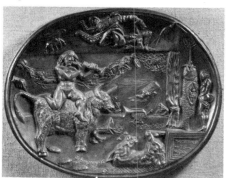

Fig. 5-1. David Smith, "Medal for Dishonor: Propaganda for War, 1939-40," Hirshorn Museum and Sculpture Garden, Smithsonian Museum.

Fig. 5-2. George Segal,
"Times Square,"
collection, Joslyn Art
Museum, Omaha, Neb.

Recent sculptures by such noted artists as George Segal, Duane Hanson, and Edward Kienholz further the spirit of Smith's work. Their large scale efforts, known as assemblages or tableaux, are made from a wide variety of materials. These works are lifelike representations of particular aspects of personal and social reality. They portray scenes from the ordinary environment of social life, mediated by the perception of the individual artist. Because the assemblage is more than a single three-dimensional object, it is conducive to social content. Each artist discussed below has used the assemblage uniquely in an effort to provide meaningful social commentary.

*George Segal
(1924-)*

George Segal (1924-) creates life-size plaster casts of human figures in elaborate, realistic settings. Associated by some critics with Pop Art—art inspired by popular sources and dealing with popular culture—Segal's work concentrates on the human condition. His assemblages clearly reflect a concern with people's feelings and emotions, especially loneliness. In this respect, his work is reminscent of the paintings of Edward Hopper.

In "Times Square" (figure 5-2), two men, apparently unknown to each other, are shown walking in this vibrant, exciting, yet seedy area of New York City. Superficially an antidote to loneliness in its population by the multitudes, Times Square can be one of the loneliest places in the U.S.

Fig. 5-3. George Segal,
"The Bowery,"
Kunsthaus, Zurich.

Fig. 5-4. George Segal, "Execution," Vancouver Art
Gallery, photo by Jim Gorman.

The neon's glitter only conceals harsh, underlying realities of urban compression. People are coldly indifferent to each other, alienated while in close proximity. The glaring advertisement for a pornographic movie underscores hidden desperation; promising only vicarious satisfaction, the skin flick also embodies the tableau's ambience of superficiality and frustration of needs.

Segal has also depicted the destitute denizens of New York's Bowery. "The Bowery" (figure 5-3) is an understated effort that nevertheless evokes a strong viewer response. Constructed in 1970, it depicts two derelicts, one standing and the other lying on the pavement in an alcoholic stupor. A common sight in every major U.S. city, drunks and their plight are casually ignored by most "respectable" citizens. A variation of that indifference is duplicated here in the attitude of the standing derelict toward his prone companion; oblivious to his fate, his concern is more likely the source of his next bottle of cheap wine.

In 1967, Segal contributed a major work to the "Protest and Hope" exhibition in New York. "Execution" (figure 5-4) is the clearest example of protest art in Segal's career. The work powerfully portrays four victims of a war-related killing. Behind them is a bullet-riddled wall. The figure at right, whose ignominious demise recalls the martyrdom of Saint Peter, hangs by his feet from a meat hook. Although the work's immediate reference is to Vietnam, it is also a generalized comment on the perniciousness of war.

Duane Hanson

The art of Duane Hanson provides an interesting contrast to that of George Segal. Far more direct and satirical in his social criticism, Hanson assaults his audience with a glaring "superrealism" that admits no ambiguity whatever.

"Super Realism"

No one can experience his works and emerge indifferent to their content. Hanson wants his art to be:

> ...a political thing. Because I can't express myself
> vocally...I do it with my work. I think society needs
> to be reformed; it is not doing things for people.*

Hanson constructed one of his most brutal works in 1968. "Riot (figure 5-5) is a bold view of racial violence in the U.S. during the 1960s. Lifesize, and uncanny in its realism, the assemblage draws the viewer into the scene. At the right, a police officer, surrounded by vigilantes, assaults a prone black man with a nightstick, symbol of authority. Enjoying his infliction of pain, the cop epitomizes a corrupt system that depends on violence to uphold its racist practices. Hanson is deliberate in his attempt to make a political statement and his

*Martin Bush, *Duane Hanson* (Wichita, 1976).

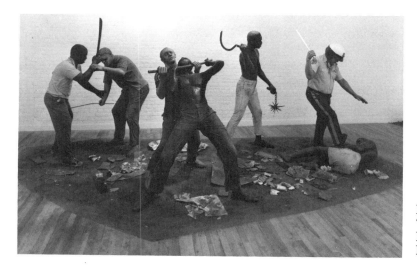

Fig. 5-5. Duane Hanson, "Riot," courtesy O.K. Harris, photo by Eric Pollitzer.

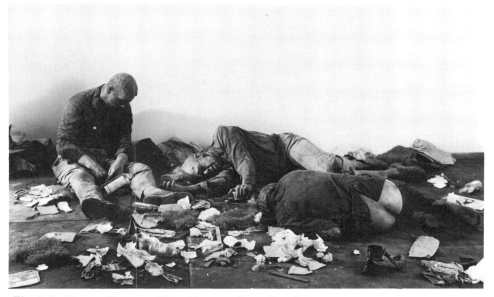

Fig. 5-6. Duane Hanson, "The Bowery Derelicts," Stadstsparkasse, Aachen, photo by Ann Munchow.

view is amply supported by the record of recent history. Anyone who observed or participated in the civil rights struggles of the past decades recognizes instantly that the scene is no exaggeration.

Hanson's sculpture "Derelicts" (figure 5-6) contrasts with Segal's work on the same theme. Life-size figures lie stupefied amid an incredible array of rubbish and dirt. Leaving no room for equivocation, the assemblage asserts a particular, sordid reality. No observer can escape the scene's visual impact. And one can almost smell the stench that emanates from the squalor. Hanson's objective is to point out a reality that the U.S. would prefer to ignore. He is willing to

risk a negative viewer reaction. For Hanson, to tell the truth artistically is inevitably to cause offense. The honesty of that position, surely, is a commendable precept of the art of social conscience.

Hanson's satirical sculpture, such as his depictions of Playboy bunnies and middle-class tourists, mock socially irresponsible values. One of his most acerbic works is a calculated assault on the consumption habits that pervade American culture. "Supermarket Lady" (figure 5-7), constructed in 1969-70, is an unflattering view of an ordinary housewife shopping in a neighborhood market. Sloppy and obese, she nonetheless stocks up on packaged foods. Sadly, she—and millions like her—is convinced of the necessity and convenience of her purchases. Utterly unaware that her "needs" have been superimposed upon her by corporate forces beyond her comprehension, she blithely sacrifices nutritional soundness and her savings in return for the shallow comfort of TV dinners.

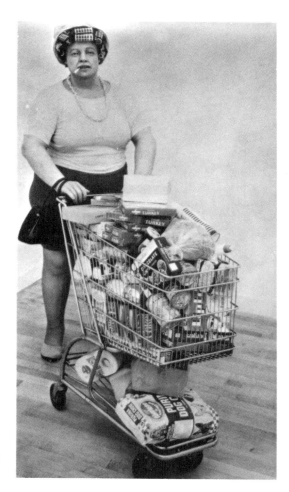

Fig. 5-7. Duane Hanson, "Supermarket Lady," courtesy the Ludwig Collection, Aachen.

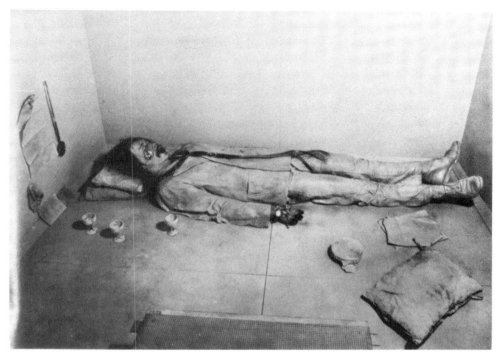

Fig. 5-8. Paul Thek, "Death of a Hippie."

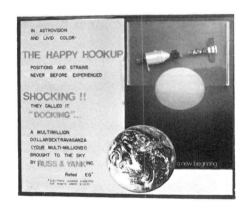

Fig. 5-9. Max Alfert, "The Happy Hookup," courtesy of the artist.

Similarly blunt is the work of assemblagist Paul Thek (1933-). Thek's observations of the youthful "counter-culture" in the U.S. during the late 1960s were manifested in a chilling work called "Death of a Hippie" (figure 5-8), a view that belies romantic notions of drug use. Thek depicts a hippie in a barren, sordid room, dead from an overdose of drugs, an image that is a far cry from the charming exuberance of cowbells and flowers. Unlike the shallow, sycophantic treatment of the hippie movement by such middle-aged academics as Charles Reich, Thek pierces the facade to discover a grim reality—epidemic abuse of drugs.

The assemblage medium also lends itself to small scale

Paul Thek (1933-)

efforts of social commentary. The works of Berkeley artist Max Alfert add an interesting dimension to contemporary developments in satirical sculpture. Viewing his products as "prop art," Alfert employs everyday images and materials in his attempt to infuse the visual arts with socially provocative content. Especially imaginative is "the Happy Hookup" (figure 5-9). An acerbic view of the joint Soviet-U.S. space venture, the assemblage is made to look like a poster for a lurid X-rated move. Alfert intentionally invokes both verbal and visual pornography, and calls attention to the monumental waste of resources involved in this international space spectacular. Conceived as much for purposes of international propaganda as it was to further science, the joint Apollo-Soyez mission was systematically sold to an informationless public.

A close view of the work reveals an even more biting aspect. At the upper right, Alfert has placed plastic models of the two spaceships as they are about to effect the hook-up. Soyez wears a miniature condom—a formal element that makes clear the true character of the rendezvous—ready to penetrate Apollo. The tryst metaphor conveys with equal effect the two governments' self-serving love affair and its impending consequences for the U.S. taxpayer.

Edward Kienholz (1927-) is probably the most important of all the socially conscious sculptors currently working in the U.S. Like Segal, Hanson, and Thek, his works are elaborate assemblages that expand the boundaries of sculpture.

As a young man, Kienholz supported himself with a variety of jobs. Although he had no formal training in art, he began to experiment with wooden relief paintings in the early 1950s. By 1958, he moved to topical issues and to the kind of mass construction that would appear later as assemblages. His first major political statement in art, "The Little Eagle Rock Incident," was a comment upon the crisis in racial integration in Little Rock, Arkansas. By the end of the 1950s, he had established a reputation as one of the most imaginative social critics.

Kienholz uses many devices to draw the viewer into the environment: sounds, smells, colors, and objects. The artist's objective is to compel the viewer's dramatic consciousness of the specific idea expressed. Like Hanson, Kienholz has little use for ambiguity: his message, dramatic and direct, is the product of intellectual precision.

Kienholz' most spectacular example of antiwar sculpture was assembled in 1968, "The Portable War Memorial" (figure 5-10). At the extreme left are the traditional U.S. symbols of war and patriotism: the U.S. Marines on Iwo Jima during World War II, the poster of Uncle Sam used to recruit soldiers

Fig. 5-10. Edward Kienholtz, "The Portable War Memorial,"
Museum Ludwig, Koln.

during World War I, and Kate Smith singing "God Bless America." The Marines are presented as robots, conditioned to follow blindly all military orders. The unflattering picture of the military is fortified by the words written on the background blackboard—the names of some 475 countries that no longer exist, a grim consequence of war. Above the blackboard is a tombstone in the form of an inverted cross. Below the patriotic figure of an American eagle, the following words appear on the horizontal bar of the cross: A Portable War Memorial Commemorating V—— Day, 19—. A piece of chalk is provided to fill in the blanks. As the artist himself has bitterly noted,* "the sculpture could be assembled, for instance, in Montreal with a 'C' in the first square and the appropriate date in the second commemorating V.C. Day (Victory in Canada), if we ever get into a serious conflict with our good neighbors to the North."

The final section of "The Portable War Memorial" is known as "Business as Usual." Two people sit at a hot dog stand, in the company of a Coca Cola machine, outdoor tables and chairs, and their small dog. The contrast of these everyday activities with the adjacent symbols of destruction leaves an impression of pervasive human indifference. Deluding themselves, the couple at the stand accept war as inevitable to the human experience, thus helping to perpetuate the kind of self-fulfilling prophecy that the artist finds so appalling.

Kienholz is equally effective in his satirical treatment of broader aspects of American culture. One of his most powerful works, "The Beanery," (figure 5-11) is a re-creation of an old Los Angeles bar, where people came to relax, to drink, to socialize, and to participate, as Celine would say, in a process of "death on the installment plan." The assemblage is a calculated assault on the senses of the viewer. Invited to walk through "The Beanery," the audience is confronted with an incredible mix of sounds, smells, colors, and forms. The Customers sit on bar stools, slowly allowing their lives to ebb away. To emphasize the point, the artist has replaced most of the human heads with clocks, symbolic of the unproductive, alienating process of "time-killing" in which the clientele indulges. Behind the bar, a pennant heralds the athletic fortunes of Slippery Rock College, Kienholz' devastating analogy to the "slippery rock" quality of of the lives of the bar's patrons.

Other details reinforce the grim view. The woman at the extreme left wears mink, apparently a desperate attempt to transcend the emptiness of her life. Her fashionable poodle adds to the situation's absurdity and sadness; again, super-

*Edward Kienholz, *11-11 Tableaux* (Stockholm: Moderna Museet, 1970), p. 105.

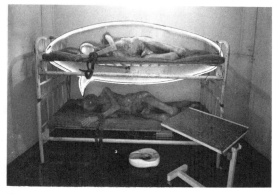

Fig. 5-12. Edward Kienholz, "The State Hospital."

Fig. 5-11. Edward Kienholz, "The Beanery," Stedelijk Museum, Amsterdam, photo by Ad Peterson.

ficial glitter is no substitute for an autonomous, fulfilling life. Finally, the sign behind the bar—"Fagots Stay Out"—attests to a common phenomenon: the seeking of minority group scapegoats by those who find their own lives inadequate. And, like some impoverished whites who derive pleasure from their hatred and persecution of blacks, the Beanery's customers, locked into heterosexual relationships, feel compelled to gain satisfaction from their supposed superiority to homosexuals.

One of Kienholz' most forceful works is "The State Hospital" (figure 5-12). Drawing upon his personal experience as an employee in a mental asylum in 1948, the artist presents a room in a mental institution in which a nude, decrepit patient, strapped to his bed, is isolated with only the brutalized image of himself for companionship: the patient's head has been fashioned into a fishbowl. The impact of this sculptural vision goes far beyond the squalid realities of institutional maltreatment of mental patients: like all the art of Edward Kienholz, "The State Hospital" reflects a more basic social malaise.

Posters, Cartoons, and Comics

These media are traditionally considered part of popular culture, seen throughout the press and elsewhere by a large percentage of the U.S. population. Accordingly, they have a potential impact far beyond the media of paintings, graphics, sculpture, and even photography that this book has thus far treated.

These works, usually topical in character, are not usually intended to have durable artistic value. Social and political comment is generally the artist's foremost consideration; because formal and aesthetic concerns are largely incidental,

it is unreasonable to criticize works in these media on the basis of traditional artistic criteria. They are inherently public, unlike traditional works of art which tend to be confined to museums, galleries, and affluent private residences. This public character, frequently viewed with suspicion and disdain by critics and art historians, should instead be seen as a favorable expansion of the social dimension in the visual arts.

The poster is both a work of art and a notice to the public. Usually intended for mass reproduction, the poster's execution is often hurried because of the immediacy of a cause. Often the poster combines a verbal message with visual stimuli designed to attract viewers. A poster's political effectiveness, in fact, often depends on efficient, inexpensive reproduction that will swiftly disseminate the work's major theme or idea.

In the past, most posters have been directed to specific commercial objectives. At the same time, posters of social protest and political revolution have also been prominent, some of enduring artistic value. Recently, posters from Cuba, France, and the United States have added an important dimension to socially conscious art. Aggressive and direct, works from all three countries have called attention to the most important problems of recent political history. The activist decade of the 1960s in the U. S. stimulated thousands of posters for various movements. From the struggle for civil rights to the war in Vietnam to the corruption of the Nixon administration, U.S. poster artists have responded to the issues. Prominent among those artists whose posters have recently made the medium a major category of the art of social conscience is Tomi Ungerer.

Tomi Ungerer
Poster artist

Born in Alsace, Ungerer (1931-) came to the United States in 1956. Starting as a book illustrator, he soon developed a wide range of artistic talents. Turning to the poster, he has executed hundreds of commercial works for a variety of enterprises. His political posters, however, are probably his best known because of their worldwide distribution. They are characterized by the kind of biting satire and humanism of such artists as George Grosz, John Heartfield, Jack Levine, Paul Cadmus, and Edward Kienholz. Colorful and imaginative, they express indignation and outrage at recent U.S. policies. Brutal and often shocking, Ungerer's posters compel one to think about the issues they raise.

Like countless other artists, Ungerer used his considerable talents to express opposition to the immoral U.S. activities in Southeast Asia. One of his most dramatic efforts is entitled "Kiss For Peace" (figure 5-13), which depicts a helpless Vietnamese victim forced to pay humiliating homage to his American masters. Like Peter Saul, Ungerer employs sexual and scatological imagery in pursuit of social com-

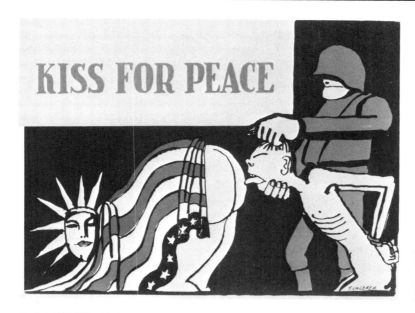

Fig. 5-13. Tomi Ungerer, "Kiss for Peace," permission Dover Publications, New York.

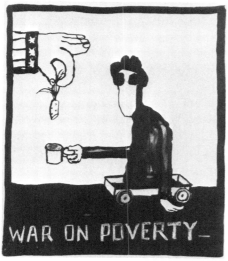

Fig. 5-14. Tomi Ungerer, "War on Poverty," permission Dover Publications, New York.

mentary. The calculated vulgarity of "Kiss For Peace," however, fades to insignificance compared to the genuine vulgarity of the war.

Ungerer's poster-commentaries on other American social topics are equally powerful. Reacting to the deficiencies of U.S. domestic policy, Ungerer satirized the widely heralded "war on poverty" (figure 5-14). In this work, the outstretched hand of Uncle Sam dangles a carrot fragment above the tin cup of a blind and crippled beggar. The way in which the carrot is held, full of distaste and scorn, is indicative of the government's attitude toward poverty-stricken citizens—the "war on poverty" mocks the poor, adding official callousness to the emotional and physical discomforts of being poor in a land of material abundance.

Poster Art

The works of other poster artists are also worthy of brief mention in this survey. One of the most chilling focused on the infamous My Lai atrocity of March 1968, when U.S. soldiers massacred more than 100 Vietnamese civilians. "Q: And Babies? A: And Babies" (figure 5-15) underscores the horror of My Lai by its title alone. Adapting a photograph of the grisly aftermath of the slaughter, the poster lets the human carnage speak for itself. Created by the Art Workers Coalition in New York, the poster was originally to be distributed with the assistance of the staff of the Museum of Modern Art. The trustees of the Museum, however, forbade the institution to associate its name with the political poster, recognition perhaps of the work's force.

The continuing ecological crisis in the United States has generated hundreds of protest posters. One captioned "Father forgive them for they know not what they do" (figure 5-16) persuasively adapts traditional iconography, calling public attention to the worsening environmental situation. Crucified on a makeshift cross formed by a spewing chimney and surrounded by rubbish, the human victim must wear a gas mask in order to survive until his inevitable demise.

Recent posters have also chronicled the women's liberation movement. Blunt and incisive, many of these works identify problems that millions of people, male and female alike, would prefer to avoid. Typical is a poster entitled "Fuck Office Work" (figure 5-17), which depicts a militant woman using a large hammer to shatter her typewriter, long the symbol of professional oppression. Violently rejecting the view that women should remain either housewives or secretaries, the poster complements the drive of women to determine their own futures.

The scandals of the Nixon Administration gave rise to a massive output of oppositional posters. "Wanted"(figure 5-18) is a response to the poor judgment, cunning immorality, and felonious conduct of Nixon and his associates. Using the format of the familiar wanted posters found in U.S. post offices, it calls attention to the reprehensible conduct of the most trusted associates of the discredited president, exploiting the gross irony of an unchecked "law and order" government that would wantonly break the law. The poster depicts twenty men involved in the Watergate affair or in one of its many offshoots. Only one figure is not listed as "apprehended." No misinterpretation of the poster's message is possible: at the top, fully cognizant and responsible for the insidious conduct of his subordinates, is Nixon himself. Executed prior to Nixon's forced resignation in 1974, the poster assumes added historical significance in light of the dubious pardon granted to him by Gerald Ford, his successor in office.

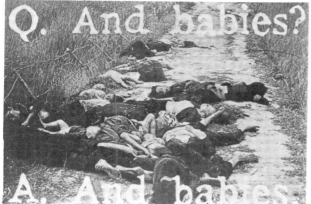

Fig. 5-15. "Q: And
Babies? A: And Babies,"
poster.

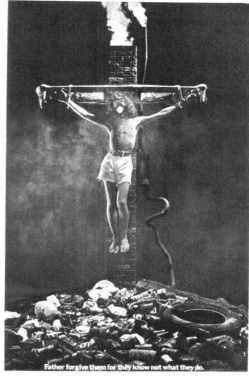

Fig. 5-16. "Father Forgive
Them For They Know Not
What They Do," poster.

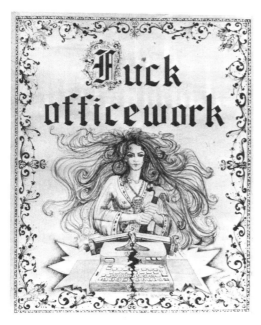

Fig. 5-17. "Fuck
Officework," poster.

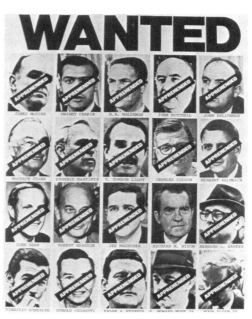

Fig. 5-18. "Wanted,"
poster.

Political Cartoons

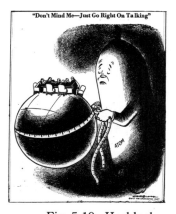

Fig. 5-19. Herblock, "Don't Mind Me—Just Go Right on Talking," permission Beacon Press.

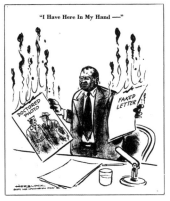

Fig. 5-20. Herblock, "I Have Here in My Hand," permission Simon & Schuster.

Closely related to the poster are the political or social cartoon and the comic strip. Even more than the poster, these daily or weekly productions necessarily suffer from the exigencies of deadlines. Only rarely do such works, directed toward other objectives, transcend their topical setting and become lasting works of art. Inherently partisan and intentionally hyperbolic, these works respond to current events from a critical vantage point; at their best, they attack, criticize, and devastate. For these artists, thankfully, nothing is sacred.

There is, of course, a substantial historical tradition of cartooning in the U.S. Thomas Nast's masterful work, as well as that of Joseph Keppler and cartoonists for *The Masses, Liberator,* and *New Masses,* has already been examined. Producing hundreds of cartoons yearly in daily newspapers, several U.S. cartoonists of the modern era have added to that burgeoning tradition. Such cartoonists as Herbert Block, Pat Oliphant, Paul Conrad, Paul Szep, and Lou Grant have been both stylistically imaginative and socially perceptive. Another group of contemporary cartoonists publish intermittently in magazines, "underground" newspapers, and in special topical collections; this group includes such artists as Ralph Steadman, Ron Cobb, Edward Sorel, Robert Pryor, and Robert Grossman.

Herbert Block (1909-), known as Herblock, is probably the dean of 20th century cartoonists. His daily work for the Washington Post has sustained for decades the tradition of artistic dissent. His drawings attain a consistently high level of artistry, and are seen by political and other leaders; like his 19th century counterpart Thomas Nast, Herblock has had a long-term effect on public opinion. His sustained assaults on such unsavory figures as Joseph McCarthy and Richard Nixon, for example, contributed to their ultimate political demise.

In an effort executed shortly after the bombing of Hiroshima, Herblock warned the world of the perils of the nuclear age. "Don't Mind Me, Just Go On Talking" (figure 5-19) is a troubling view of what could happen if political negotiations among world leaders were to break down. In the cartoon, a world unduly prideful that it has "taken the atom's measure," finds its own measure taken by "Mr. Atom;" humanity is here controlled by, rather than in control of, its scientific discovery.

Herblock's opposition to McCarthyism was a courageous exception to the fear and passivity of that era. Virtually all of his anti-McCarthy cartoons are outstanding examples of social protest art. Typical is a work executed in 1954 entitled "I Have Here in My Hand—" (figure 5-20). Using the Wisconsin Senator's own deceptive words, Herblock exposes

McCarthy's dishonest, self-righteous methods in accusing countless citizens of "un-American" activities. The Senator's thug-like appearance mirrors the loathing that Herblock obviously felt for his subject.

Herblock has maintained a vigorous opposition to corruption and injustice throughout the present period. An early critic of Richard Nixon, Herblock's savage pen alerted the public to the chicanery occurring in Washington, D.C. From the time of Nixon's first inauguration until his departure from office in disgrace, Herblock created scores of cartoons criticizing him, his associates, and his nefarious policies. In one sardonic example, he depicted President Nixon and Attorney General John Mitchell as a giant scissors, striding arrogantly across the national landscape. Labelled "Attempted Censorship," the scissors and its scale reveal the dangers to U.S. constitutional rights posed by the Nixon administration. In his vigorous defense of freedom of the press, Herblock joins a distinguished thematic tradition in the history of socially conscious art.

The sordid Watergate affair generated one of the most massive outputs of cartoons in history. Ironically, Richard Nixon's greatest contribution to the nation's cultural life lay perhaps in his unwitting encouragement of poster and cartoon art. Although it is difficult to settle on one example of Watergate-related cartooning, the work of Ralph Steadman merits serious consideration. He executed a savage portfolio of cartoons on Watergate for *Rolling Stone* magazine, an excellent example (figure 5-21) of which shows the President about to be hanged by the famous tape recordings that sealed his political fate. Glumly contemplating the inevitable, Nixon mutters "Aw Shit," appropriately reminiscent of the kind of language, captured on the tapes, he used so incessantly. Steadman's work is calculatingly and suitably ugly.

Another cartoonist, Ron Cobb, creates cartoons that are biting and accurate commentaries on the inequities in society. An example of Cobb's work (figure 5-22) demonstrates his

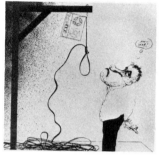

Fig. 5-21. Ralph Steadman, "Watergate," courtesy of the artist.

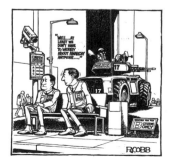

Fig. 5-22. Ron Cobb, "Well...at least we don't have to worry about anarchy anymore...," courtesy Wild & Woolley, Australia.

profound concern with the quality of human life, as it details an Orwellian nightmare in the United States. Labelled as citizens "A," "B," and "C," the populace has exchanged freedom for the stultifying security of a totalitarian order. The rules are explicit and the police stand ready to enforce the unyielding conformity. Produced during the 60s, the cartoon follows reactionary "law and order" rhetoric to its logical conclusion.

In the present era, there is no finer caricaturist-cartoonist than David Levine, whose magnificent work appears regularly in *The New York Review of Books*. Levine has parodied virtually every major politician and literary figure in the modern era. Perhaps his most famous caricature was that of President Lyndon B. Johnson, primary architect of the war in Vietnam (figure 5-23). Executed in 1966 during the height of military escalation, the work shows the President pointing to a Vietnam shaped scar on his stomach. The reference point for the work was an actual incident in which Johnson, recuperating from an operation, displayed his scar to a group of reporters. Savage in intent, the work is one of the most memorable artistic protests against that national scar, the "war for Democracy."

During the Nixon era, Levine engaged in a relentless assault on the felonious Vice-President, Spiro T. Agnew. One sardonic view shows Agnew piecing together a picture puzzle of Senator Joseph McCarthey, a man whose strident right-wing rhetoric he shared.

The works of Jules Feiffer stand on the vague borderline between political cartoons and comic strips. Comic strips, largely a 20th century innovation, are among the most popular of newspaper features. Until the recent works of such artists as Feiffer, the little social or political commentary that existed in U.S. comics generally supported the status quo, however unprogressive.

Feiffer himself is a highly imaginative cartoonist—as well as an accomplished writer—whose penetrating insights have made him one of the medium's premier figures. The verbal features of Feiffer's works are as important as the pictorial ones, as demonstrated by a bitterly poignant cartoon on Vietnam (figure 5-24). In this work, the origins of U.S. involvement in the war are traced from President Kennedy to Johnson to Nixon. Each president utters the platitudes that concealed the reality of the actual conflict in Asia; meanwhile, young boys grow up and are slain, while the Chief Executive prattles on. Feiffer employs the paneling technique effectively in chronicling the war's successive tragic stages.

Like almost every thoughtful U.S. cartoonist, Feiffer found Richard Nixon an irresistible target. An example from 1973 (figure 5-25) shows the president giving criminal instruc-

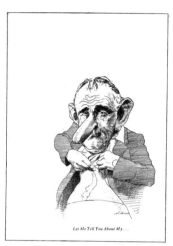

Let Me Tell You About My . . .

Fig. 5-23. David Levine, "Let me tell you about my...," ermission from *The New York Review of Books*.

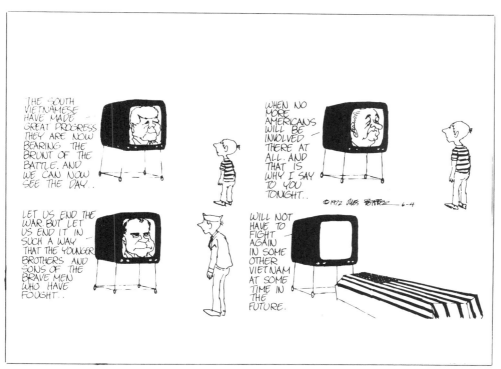

Fig. 5-24. Jules Feiffer, cartoon by permission of Jules Feiffer.

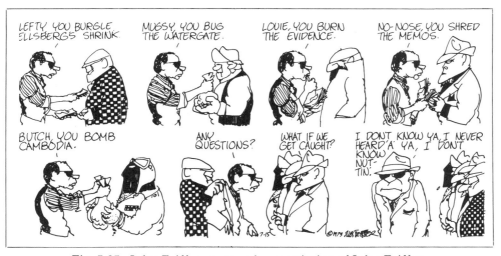

Fig. 5-25. Jules Feiffer, cartoon by permission of Jules Feiffer.

tions to several shady subordinates. Using the verbiage and visual images popularly associated with organized crime, Feiffer's dramatization serves to heighten public awareness of the Watergate scandal. More witty than bitter, the cartoon is a fine example of the medium's topical mission.

Murals

Murals

In the past two decades, there has been a renaissance of public mural art throughout the United States. In virtually every major city, and in scores of smaller cities and towns, artists have created murals of impressive artistic stature and dramatic political impact. The present mural movement is rooted deeply in the Mexican murals of the 1920s and in the Depression murals of the 1930s. Many of today's murals call attention to a vast complex of social ills. Above all, they are expressions of the daily lives of millions of people.

Most contemporary murals in the United States are heavily political. Socially engaged mural artists view their works as aids to social cohesion and political awareness in the communities in which they work. Accordingly, they usually seek neighborhood participation in a mural's planning and execution. Young people, some of whose artistic activities have been confined to spray-painted graffitti, assist mature artists in large scale artistic expression. The effect of this collaboration is to create a genuine feeling of community solidarity.

Murals have a potential impact far beyond that of the vast majority of art works appearing in this book. Their presence on interior and exterior walls of major buildings makes them easily accessible to large numbers of people who live and work amongst them.

Since most social muralists today are acutely aware of the historical sources of their work, a brief review of the Mexican mural experience developments is useful here. In Mexico during the 1920s public murals reappeared for the first time since the High Renaissance. Early in the decade, General Alvaro Obregon's government brought a measure of political stability in the wake of the violent Mexican Revolution. Obregon's minister of education, Jose Vasconcellos, was an imaginative, vigorous intellectual who stimulated the cultural life of the nation by turning the walls of public buildings over to mural artists. Diego Rivera, Jose Clemente Orozco, David Alfaro Siqueiros and other muralists were placed on the public payroll, and used their art to criticize the very institutions that sustained them.

Throughout the 1920s and 30s, these artists scathingly attacked the Church and capitalism and commented upon the Mexican Revolution and the progressive forces of socialism. The influence of muralism combined with social criticism

spread rapidly, most notably to the United States. All three of the major Mexican muralists travelled extensively in the U.S., creating impressive works of mural art. Equally important, U.S. artists journeyed to Guadalajara and Mexico City to learn from their Mexican colleagues and, on occasion, to participate in mural projects. The American Social Realist George Biddle, for example, executed a mural for the Mexican Supreme Court Building during the 1940s. Entitled "War." the work was a biting commentary on brutality, violence, and human suffering.*

The enormous impact of the Depression upon U.S. art has already been noted. Especially significant was the Roosevelt administration's role in supporting the arts and artists. The Works Progress Administration employed hundreds of artists nationwide including many who would become figureheads of modern art. Work in every medium was encouraged, but most of all the creation of murals in public buildings in U.S. cities and towns.

The Mexican influence was obvious—although WPA murals were not as consistently political as those in Mexico—and murals were created in staggering numbers. Some were decorative while others were simplistic expressions of traditional American faith in technology and progress. There are hundreds of murals that show man and machines jointly propelling the nation out of the Depression. Yet there were also numerous WPA murals evidencing critical social commentary. Along with Mexican works, they exerted a substantial influence on American mural developments from the late 1960s to the present. Such artists as Evergood, Shahn, Gropper, Marsh, Kent, Soyer, and Refregier as usual incorporated social criticism into their murals. Some artists found themselves in political difficulties because of the content of their works. In fact, Shahn, Kent, Refregier and others encountered attempted institutional censorship. Clearly, the public character of their murals was perceived as far more threatening than any privately-held single graphic work. Nearly simultaneously, Diego Rivera's Rockefeller Center mural—a work replete with images of Communist ideology— was destroyed because of its objectionable political content.

A brief survey of some of the highlights of socially conscious murals of the 1930s will further understanding of the present revival. San Francisco was a major center for such works. Artists like Victor Arnautoff, Clifford Wight, and Bernard Zackheim created a series of mural panels on the walls of the city's famous Coit Tower, works that caused considerable controversy. Called "Communist propaganda,"

*For further treatment of the Mexican muralists and their works, see Von Blum, *The Art of Social Conscience* (Universe, 1976), Chapter 6.

Fig. 5-27. Victor Arnautoff's detail from Coit Tower Mural, San Francisco W.P.A.

Fig. 5-26. Bernard Zackheim's "Library" detail from Coit Tower Mural, San Francisco WPA.

the murals were threatened with obliteration. In response, the San Francisco Artists and Writers Union mobilized to protect the right of free artistic expression. Eventually, the furor ebbed and the murals were permitted to remain.

The Coit Tower murals are typical of the social orientation of much Depression art. A detail of a work by Bernand Zackheim (figure 5-26) shows several men reading newspapers which display various headlines of political importance. The panel's controversial feature depicts a man in worker's clothing selecting a copy of "Capital" by Karl Marx. Of course, such an interest in Marxism was perceived as a great threat by San Francisco conservatives.

Panels by Victor Arnautoff were even more provocative, depicting the patterns of daily city life in highly critical fashion (figure 5-27). In the center of the work, a man is robbed by two thugs in an unflattering if realistic portrait of urban existence. In the background, a serious automobile accident has caused injury and confusion. While hardly an assault on the entire social order, the effort does evidence some of the realistic attention to social problems that characterize much contemporary American mural painting.

In New York, WPA artist Lucienne Bloch was assigned to paint a mural for the New York Women's House of Detention. She decided to create a work that would reflect the lives and experiences of the institution's female inmates. The

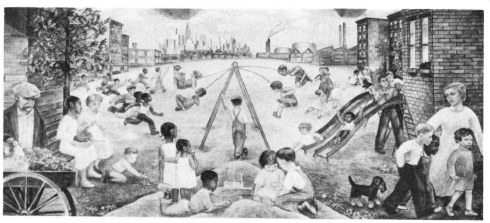

Fig. 5-28. Lucienne Bloch, "Childhood," mural.

result was a mural entitled "Childhood," (figure 5-28). The work is especially notable because it portrayed black and white children playing together, then even more than now a controversial conception. This theme of racial solidarity would appear in scores of contemporary murals.

Until recently, the flowering of Abstract Expressionism, committed to expression of individual tendencies, encouraged the decline of the social art of mural painting. The social and political turmoil of the 1960s once again stimulated creation of public art that would appeal to a wide audience; the struggle for civil rights and the war in Vietnam, in addition to generating thousands of posters and cartoons, served to catalyze a mural renaissance.

Groups of muralists have developed in most major U.S. cities. At present, there is little literature on these groups and only recently has there been communication between them. The National Mural Conference held in New York in 1976 helped to forge a coherent identity for the mural movement and to identify the major problems and prospects for future artistic and political developments of modern muralism.

There is an intimate connection between the mural movement and the complex problems besetting U.S. cities. Massive unemployment and physical squalor produce unhealthy living conditions for millions. Cities are centers of crime, drug addiction, and racial oppression. Recently, however, minority groups most affected by these conditions have organized politically. Many of these groups have used public art as a major consciousness-raising device, making it part of a comprehensive program to improve the quality of their lives. A major strain of murals today exhibits ethnic anger and community pride in cultural history generally unknown to the majority population. Contemporary muralism there-

fore acts as a major extension of ethnic consciousness in U.S. social art.

Murals, emerging from the experiences and deeply felt needs of people, are viewed with enormous community pride. They are often used as rallying points for political protests, neighborhood meetings, and ethnic celebrations. For most socially-oriented muralists, these uses for murals are even more important than the works' durable artistry. Indeed, most murals are created with the expectation that they will last no more than five or ten years, since they are susceptible to adverse weather conditions, pollution, and urban construction.

Since they are inseparably related to the daily lives of people in a broader social context, it is fruitless to apply standard art historical criteria in the evaluation of murals. Although social muralists rarely ignore artistic considerations, they are properly tempered by political and social commitments and by the need for community mobilization. The manner in which art affects the lives of human beings is surely as important as such formal elements as line, form, and color. As in all art of social conscience, reliance on form alone would render the critical process little more than an empty academic exercise.

It is appropriate to begin a review of current mural development with a treatment of mural activity in Chicago. The present renaissance of social mural art began in that city when the 1967 "Wall of Respect" was painted in a ghetto area under the direction of William Walker. Since that time, Chicago has been in the forefront of the mural movement. Several mural groups have formed close relationships with local communities. Such groups as the Public Art Workshop, the Chicago Mural Group, and the Movimento Artistico Chicano combine outstanding artistic talent with sophisticated politics. Committed to the use of art as a mechanism for general social and political change, each also seeks to call attention to specific problems besetting Chicago.

Numerous Chicago murals highlight the heroes of black and latino history, generating community pride in the achievements of ethnic leaders of the past. The murals also help create solidarity among ethnic groups that all too frequently fight each other instead of forming alliances against common oppression. A few years ago, groups of Puerto Ricans and Mexican-Americans engaged in savage gang warfare against each other. Exacerbated by rivalries in drug dealings, the struggle caused numerous injuries and deaths. In an attempt to end the battles, a group of mural artists created a work attempting to ally the rivals. Under the direction of muralist Ray Patlan, the "Mural de la Raza" was executed. In the detail presented (figure 5-29), two prominent historical fig-

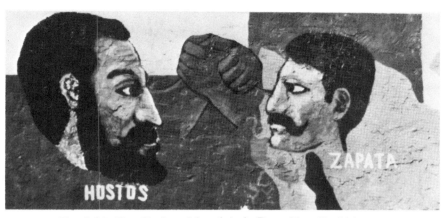

Fig. 5-29. Ray Patlan, Mural de la Raza (detail), Chicago.

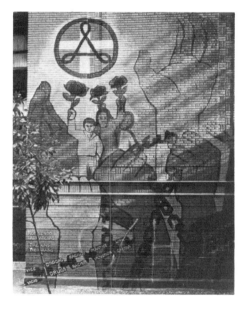

Fig. 5-30. John Weber, "Breaking the Chains," mural, Chicago.

ures clasp hands in a symbolic gesture of solidarity. On the left is Eugenia M. de Hostos, famous Puerto Rican agitator for self-determination; on the right is Emiliano Zapata, equally famous Mexican activist for agrarian reform. This powerful public expression of mutual friendship had a significant effect in calming the tensions of the rival hispanic communities.

Another Chicago mural treating the theme of racial unity was directed by prominent social muralist John Weber. "Breaking the Chains" (figure 5-30) highlights the kind of human solidarity necessary to effect change. The forceful composition is aided by the addition of a bilingual list identifying the evils to be overcome: vice, drugs, racism, injustice, and war. Like all socially-oriented murals, the work is concerned with realities and experiences of the local community.

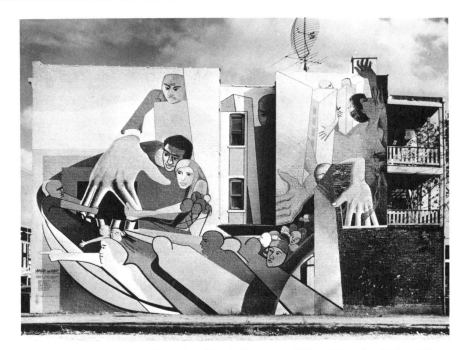

Fig. 5-31. Mark Rogovin, "Breaking the Grip of the Absentee Landlord," mural.

The 1973 mural "Break the Grip of the Absentee Landlord" (figure 5-31) was created under the direction of Mark Rogovin of the Public Art Workshop. The mural addresses an issue directly relevant to the lives of thousands of blacks in Chicago and elsewhere. The absentee landlord is often responsible for apartments with inadequate heating, poor lighting, defective sanitation, and a myriad of other problems. Concerned only with financial exploitation, his abuses make life even more miserable in the ethnic ghettos of the U.S. In this work, Rogovin portrays the landlord holding the people's homes in an iron grip. The people begin to break that grip, while others, at the left, escape their bondage. The work combines artistic proficiency with a didacticism that may inspire community action.

Other social topics also find expression in Chicago mural paintings. A visually exciting work entitled "Bored of Education" (figure 5-32) is a persuasive satire on the nature of public education. Created by Marie Burton and several assistants, the mural depicts a mechanistic educational process that stamps out an unending number of uncritical automatons. The work criticizes a system that, instead of encouraging students to examine social inadequacies, attempts to indoctrinate them with a facile inhibiting patriotism. Burton's effective use of American flag imagery and the punning title pointedly highlight the defects of our educational system.

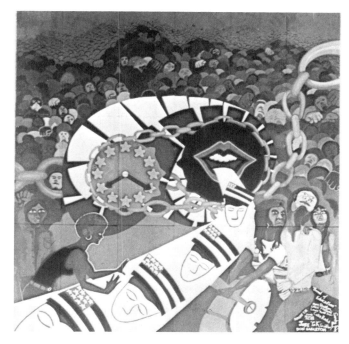

Fig. 5-32. Marie Burton, "Bored of Education," mural, Chicago.

New York is another major center of socially conscious mural work. In recent years, two major strains of mural art have developed there. One of these is usually spearheaded by a group called City Walls, an organization that searches for available walls on which to paint giant abstract works. This group's impressive works are exciting innovations in modern art and add significant aesthetic refreshment to the grimness of much contemporary urban life. Their presence, however, raises one problem of considerable importance: these pleasing abstract murals may tend to deflect attention from the terrible conditions of New York existence even if, on balance, it is better to have them than not.

New York's other major strain of mural art is more closely aligned with social conscience and is exemplified by the efforts of City Arts. Operating in the heart of the multi-ethnic Lower East Side, this organization has generated considerable involvement by the surrounding community. Jews, Blacks, Puerto Ricans, and Chinese-Americans have all used murals to express cultural pride. These works are bright, aggressive, and thoughtful.

Typical is the "Jewish Ethnic Mural" (figure 5-33). Completed in 1973, the work chronicles the historical struggles of Jewish immigrants for economic and social justice. Details include the hardships of immigration, the formation of labor unions, and the diversity of the Jewish tradition in the United States. As in many murals, verbal features complement the pictorial images, intensifying the work's impact.

Fig. 5-33. Jewish Ethnic Mural, City Arts Workshop, New York.

An effort entitled "Wall of Respect for Women" (figure 5-34) adds a feminist component to New York's mural scene. Colorful and vibrant, the mural depicts the various roles of women throughout U.S. history. Attentive not only to women in their traditional roles as mothers and homemakers, the mural also extols their contributions as labor organizers, factory workers, and teachers. And the top of the mural reflects the theme of racial and cultural harmony found throughout the mural movement.

Like their counterparts elsewhere, New York social mural painters often comment on topical issues vital to the community. A striking example confronts New York's ubiquitous problem of drug abuse. The "Anti-Drug Abuse Mural" (figure 5-35), with its simple silhouettes, presents a powerful warning to the viewer. Placed strategically in a schoolyard, the work shows many horrible consequences of drug abuse. Highlighting such unpleasant realities associated with drug abuse as violence and arrest, the mural's real significance, perhaps, lies in its origin: created by community members for community members, it bears no taint of governmental coercion.

"The Impact of Federal Budget Cuts" (figure 5-36), the dark colors of which communicate impending crisis, focuses on the human consequences of national political and economic policies. Denying the poor even minimal financial support, government cutbacks affect millions of people in deeply personal ways. The mural, effective as political propaganda, is also artistically impressive.

Fig. 5-34. "Wall of Respect for Women," City Arts
Workshop, New York.

Fig. 5-35. Anti-Drug Abuse Mural, City Arts Workshop,
New York.

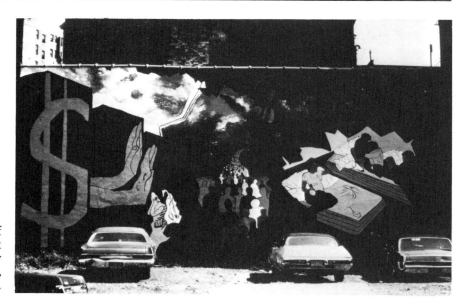

Fig 5-36. Impact of Federal Budget Cuts Mural, City Arts Workshop, New York.

Philadelphia, too, has been a center for significant mural work. One major mural project is headquartered in the Department of Urban Outreach of the Philadelphia Museum of Art. This unit successfully solicits community participation both in selection of the mural's topic and in painting it; the resulting murals are both decorative and political. In one instance, Urban Outreach helped a Chinatown neighborhood prevent the destruction of America's oldest Chinese church through creation of an effective, propagandistic mural. Designed by artist Sharon Lowe and painted by the Chinese Youth Coalition in 1973, the work (figure 5-37) depicts a fiery dragon rising in furious opposition to the instruments of destruction. The mural's passionate commitment to an issue of local concern is representative of contemporary social muralism.

West Coast muralists have also participated in the mural renaissance. In San Francisco, several mural groups have traversed the city's neighborhoods in an attempt to infuse art into the people's daily life. Their objective, like that of their colleagues nationwide, has been to enhance communities aesthetically and to inform residents of important social, political, and historical issues.

San Francisco muralism, in its present stage, was initiated in the early 1970s in the Mission District, a community inhabited by a large Spanish-speaking population. Much mural painting there is done jointly by artists and residents. Because the content of these works is intimately connected with the lives of Mexican-Americans, it is natural that the Mexican mural experience of the 1920s and 30s is its primary source of inspiration.

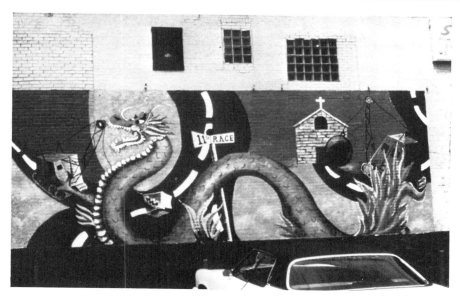

Fig. 5-37. Sharon Lowe, Philadelphia Chinatown Mural, painted by Chinese Youth Coalition.

Numerous Mission District murals highlight the tensions of barrio life. An imaginative effort was painted on the exterior wall of the Neighborhood Legal Assistance Foundation (figure 5-38). Using the familiar format of the comic strip, the mural proceeds linearly. Showing a group of Chicanos being arrested by two pig-faced police officers, the mural calls attention to the relentless pattern of police harrassment in minority communities throughout the U.S. The artist himself, Mike Rios, has often been stopped without cause by the police.

A group of murals at a local school and recreation center further distinguish the San Francisco mural revival. These interior works are colorful and socially critical. Most panels focus on the difficulties of life in the Mission District, including drug addiction, poverty, and police harrassment; others focus on the tragic wars in Biafra and Vietnam. Figure 5-39, by muralist Tom Rios, is a moving view of the human suffering caused by war. An anguished women, her child, and a dead body behind them reveal the human cost of the Vietnam conflict. The background land is desolate, yet another reminder of the horror that lasted for more than two decades. An ominous skull in the work's center underscores the mural's message.

Los Angeles has similarly been at the modern mural movement's forefront. Many exciting murals are found in East Los Angeles, home of hundreds of thousands of Mexican-Americans and Mexican nationals. Like works in San Francisco, Chicago, and New York, these murals depict the complex of social, economic, and political problems that dominate life in the barrio. Los Angeles muralists use their own expe-

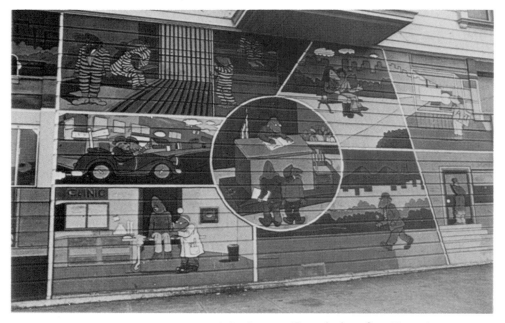

Fig. 5-38. Neighborhood Legal Assistance Foundation, San Francisco.

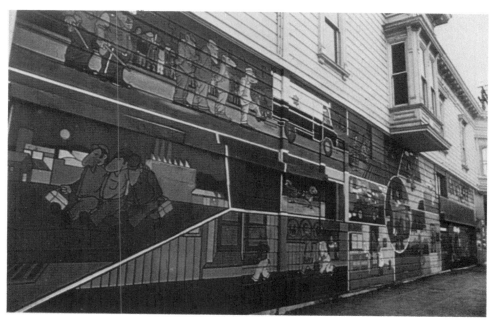

Fig. 5-38. Neighborhood Legal Assistance Foundation Mural, San Francisco.

Fig. 5-39. Tom Rios,
Mural detail,
Jamestown, San
Francisco.

Fig. 5-40. East Los
Angeles Mural of Benito
Juarez, Pancho Villa, and
Emilio Zapata.

riences to treat such topics as poverty, drugs, racial discrimination, and personal sorrow. Like muralists everywhere, they hope to stimulate a broader consideration of these issues in their communities.

Historical topics, too, are frequently depicted in East Los Angeles murals. Available wall space, however small, is enthusiastically used to communicate to inhabitants of the barrio the fervor of the Mexican past. A striking example (figure 5-40) shows three important Mexican figures: Benito Juarez, Pancho Villa, and Emiliano Zapata. The dignity and understated simplicity of the mural work better than would any more grand conception.

There are hundreds of outstanding social and political murals in other cities and towns in the United States. This exciting resurgence of mural art has already effected notable changes in American political and aesthetic consciousness in recent years. The U.S. mural renaissance is the result of the labors of artists who refuse to remain indifferent to contemporary social injustice and political misconduct.

A distinctive strain of socially conscious art in the U.S. is concerned with the history, struggles, frustrations, and aspirations of various ethnic groups. The contributions these groups have made to the nation's history have been recognized to a certain extent. However, it took the activist decade of the 1960s to generate widespread public acceptance of ethnic consciousness. This concluding chapter will cover broadly the ethnic subset of the art of social conscience. The chapter's case study format will allow more comprehensive, thematic treatment than heretofore possible in our decade-by-decade historical approach. Such a format may also be useful for further scholarly work, and it should be emphasized that the choice here of Afro-American and Jewish ethnic art is somewhat arbitrary. Indeed, materials exist for similar studies in many other areas, such as a much-needed historical and critical treatment of feminist art.

A valuable byproduct of this "new" ethnic consciousness has been a more serious and thoughtful evaluation of ethnically topical art. For many years, the artistic endeavors of ethnic groups were considered marginal and uninteresting, and largely irrelevant to the development of American art history. Like socially conscious art in general, ethnic art has often been dismissed because of its highly partisan character and because of its didacticism.

Collectively, the work of the artists who follow has expanded the horizons of U.S. social art while it has promoted a general awareness of the problems of ethnic minorities. Educative for the dominant, white, middle-class majority in the U.S. as well as for ethnic groups, these artists would bring to light historical events of which many people are ignorant or prefer to ignore.

The Afro-American Experience

Afro-American art has had a long and honorable history in the U.S. Its roots go back as far as the history of the country. But even though Black artists in the United States have created thousands of outstanding works, their accomplishments are only beginning to receive full recognition. University courses on Black art, for example, are still too rare and museums have too seldom exhibited Black artists' works; Black artistic productions have too often been denied consideration as fine art. The time has come, surely, for a more realistic and less racist perspective. The Black artistic tradition converges with the tradition of American socially conscious art insofar as it expresses a critical view of the oppressive features of life that Blacks have endured. The major historical catalyst for this convergence was the Great Depression.

CHAPTER 6
A CASE STUDY IN THE ART OF SOCIAL CON SCI ENCE
THE AFRO-AMERICAN AND JEWISH EXPERI-ENCE

A few years earlier, however, in the 1920s, a Black cultural heritage was "discovered." "Harlem Renaissance" describes this period of enormous ferment, revolt, and experimentation; the era saw Black music, art, literature and scholarship generated at an unprecedented rate. Spurred by Black migration out of the Deep South and into the urban metropolises, the "Renaissance" marked a major change in the attitudes of U.S. Blacks toward the society in which they lived: paternalism and dependence were slowly replaced by concern with self-reliance, self-respect, and ethnic pride.

Harlem Renaissance

The Harlem Renaissance was predominantly a literary movement, spearheaded by such writers as W.E.B. DuBois, Langston Hughes, Claude McKay, Countee Cullen, Arna Bontemps, and Zora Neale Thurston. These literary figures had impressive counterparts in the visual arts. Perhaps the most important was the Columbia University trained Aaron Douglas. His works capture the dignity of Black men and women and stand as the finest visual record of the Harlem Renaissance. Steeped in the traditions of African art, Douglas' cover jackets and plates for books by Langston Hughes, James Weldon Johnson, Alain Locke, and Countee Cullen are an integral part of 20th century Afro-American art and culture. Douglas' murals depicting themes in Afro-American history, executed in 1934 under the auspices of the Works Progress Administration, were ethnic counterparts to the emerging tradition of Social Realism.

The Depression, not surprisingly, hit the Black population with devastating severity. The excitement of the Jazz Age and of the Harlem Renaissance faded, supplanted by concern with economic survival. Day to day existence was harsh and unpleasant, and these new realities found expression in art, literature, and journalism; social and political topics were emphasized.

Aaron Douglas

A 1934 mural by Aaron Douglas, "Aspects of Negro Life," graces the walls of a branch of the New York Public Library. The work depicts some of the African artistic and cultural background of American Blacks, the abolition of slavery and the violence of the Ku Klux Klan, the recurring horrors of lynching and oppressive toil in the South, and the migration of thousands of Blacks to the industrialized North during World War I.

Panel 2 of the four-panel mural (figure 6-1) concentrates on the period including slavery and Reconstruction. At the right, freedom is celebrated by a jubilant dancer and trumpeter. In the center is a dignified Black orator, symbolic of the new political rights that were supposed to prevail. In the background, a line of soldiers march, denoting Civil War strife. Finally, at the extreme upper left, the emerging specter of the Klan is present, a post-Reconstruction force that would

Fig. 6-1. Aaron Douglas, "Aspects of Negro Life," courtesy of New York Public Library.

institute a new wave of terror. It should be noted that the "Reconstruction" alluded to in Douglas' work, though it officially brought liberty, also created new networks of Black dependence by debt and terror. Similarly, the more recent migration of Blacks to urban centers has merely spurred the creation of ghettos, dual labor markets, and pressure-abating welfare programs; and those gains made by Blacks in the 1960s have also been severely cut back.

The social orientation of the work of Douglas and other artists was encouraged by government sponsorship of the arts through the WPA. Black artists in the program were accorded equal treatment and respect. Highlighting Afro-American life and history, these artists made distinctive contributions to federal art projects and to the emerging force of socially conscious art.

Jacob Lawrence, (1917-) a prominent figure in the Black artistic tradition, was also active early in the Social Realist movement. Heir both to the Harlem Renaissance and to the Depression, Lawrence was equally influenced by the pathos of life in the ghetto and by the humanist works of such masters as Brueghel, Kollwitz, Rivera, and Orozco. Lawrence portrayed the Black experience more effectively and with greater force than any other artist in America.

Jacob Lawrence (1917-)

The foremost characteristic of Lawrence's work is his use of series of narratives to chronicle and interpret the historical struggles of Blacks. Early series deal with key figures in liberation movements, depicting Toussaint L'Ouverture, Frederick Douglas, and Harriet Tubman. Subsequent works comment upon contemporary history and the hardships of social life in the urban North. Lawrence's works consistently demonstrate the urgency of using art for political and social instruction.

Fig. 6-2. Jacob Lawrence, "General Toussaint L'Ouverture," part of the Aaron Douglas Collection, owned by the American Missionary Association.

An excellent example of Lawrence's early work is his portrait of Toussaint L'Ouverture (figure 6-2). The painting is a bold and vigorous view of the black leader and military genius who won independence for Haiti in 1804 by defeating a large Napoleonic army. As a result of this rebellion against France, thousands of Black slaves were freed and the colonial oppressors were either killed or forced to flee. Lawrence's painting of an extraordinary Black leader was an early attempt to generate ethnic consciousness and pride among his fellow Blacks.

"Migration," one of Lawrence's powerful series begun in 1940, is a comprehensive account of the World War I movement of Blacks from the rural South to Northern urban centers. These sixty paintings, replete with hope and social criticism, portray the human consequences of massive demographic change. Lawrence exposes both the economic injustice and violence of life in the South and the difficulties of

urban adjustment in the North where racism was becoming newly institutionalized. The excitement and joy of thousands of Blacks turned quickly to grief and despair as they were cramped into squalid urban tenements. Panel 10 of the "Migration" series (figure 6-3), entitled "They Were Very Poor," was an equally apt depiction of conditions facing U.S. Blacks in both the rural South and the urban North. The composition's stark simplicity emphasized the hunger of the two figures.

As a young child in Pennsylvania, Horace Pippin (1888-1946) was attracted to drawing, but received no artistic instruction because his family could not afford it and because no courses were offered in his segregated school. As a result, Pippin developed his own "primitive" style, joining the select company of other primitivists who have had a significant impact on the history of U.S. art.

*Horace Pippin
(1888-1946)*

Pippin worked for several years as an unskilled and semi-skilled laborer. At the outset of U.S. involvement in World War I, he enlisted in the U.S. Army and was sent to France to fight in an all Black unit. His experiences at the front lines were frightening and traumatic, leaving him with images and memories that would last his entire lifetime. His right arm was wounded in combat, and this injury threatened to end his artistic career prematurely.

Returning to the U.S. with a modest disability pension, Pippin grieved for several years about his inability to paint. Finally, after discovering a technique that would allow him to work despite his injury, his first efforts expressed his

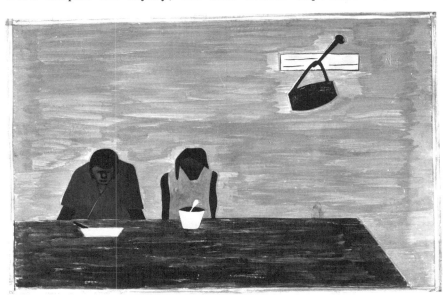

Fig. 6-3. Jacob Lawrence, "Panel 10, Migration Series," collection the Museum of Modern Art, New York, gift of Mrs. David M. Levy.

reactions to the war. "Drawing" on wood with a supportive red hot poker and then painting with left hand supporting right, Pippin highlighted the lives of beleaguered Black soldiers fighting World War I; and his paintings revealed with equal power the desolation and destruction of war in general.

Horace Pippin, like Jacob Lawrence, was attracted by the story of the the abolitionist John Brown. A fiery advocate of freedom, Brown organized the 1859 raid on Harpers Ferry, West Virginia, to obtain weapons to fight the slaveholding states. Brown's raiding party captured an arsenal, but after two days of intense fighting, was defeated and arrested. Brown was tried, convicted, and sentenced to hang, an execution at which Pippin's grandmother was present. His eloquent abolitionist statements before hanging made him a hero to thousands of Black people.

Pippin painted a series of works concerning John Brown, the most notable of which is "John Brown Going to His Hanging" (figure 6-4). Bound in rope and seated on a coffin, Brown is transported to the gallows. The cold winter day and the barrenness of the trees suggest a mood of resignation and sadness. The expression of the Black woman at the lower right is one of anger, and she turns her back to the death wagon. The woman symbolizes the rage and grief felt both by Blacks in general and by the artist himself.

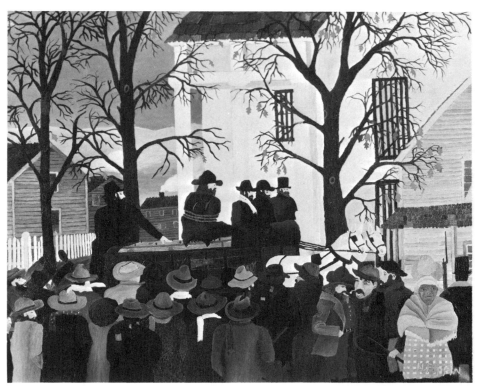

Fig. 6-4. Horace Pippin, "John Brown Going to His Hanging," Pennsylvania Academy of the Fine Arts, Lambert Fund Purchase.

The onset of World War II stimulated Pippin to express again his powerful antiwar sentiments. Toward the end of his life, he conceived and executed a series entitled "The Holy Mountain." Like Edward Hicks' works of a century before, the paintings were based on the Bible's book of Isaiah and were moving pleas for a peaceable kingdom. Pippin ended his life having achieved a remarkable amount of fame considering his relatively short professional artistic career; at his death, his works figured prominently in the collections of many leading American museums.

Charles White (1918-1979), born and raised in Chicago, witnessed firsthand the wretched conditions of poverty and racial discrimination. White's talents were apparent at an early age, and after years of frustration—developing his art while barely surviving economically—White finally received formal training at Chicago's Art Institute. His reputation grew and he soon became one of the finest black artists in the United States.

*Charles White
(1918-1979)
Painter & lithographer*

White's work has focused on the conditions and experiences of Blacks and has displayed a consistent humanism. Most of his works are drawings and lithographs, although he is also an accomplished muralist and easel painter. His 1943 mural at the Hampton Institute in Virginia, "The Contribution of the Negro to American Democracy" is an outstanding use of the medium, dynamically expressing the achievements of Blacks in cultural, political, and intellectual endeavors.

An oil painting from 1946, "Two Alone" (figure 6-5), is a fine example of White's stylistic and thematic concerns. Emphasizing the human element, the artist paints a compassionate portrait of a Black couple trying to forge a fruitful and satisfying existence in the face of prejudice and economic hardship. The figures' expressions bespeak their frustration and sadness. At the same time, however, the couple's determination to overcome the odds is made perfectly clear. Sustained by genuine love and mutual respect, they project an optimism that characterizes much of White's art. White has said of this emphasis on the positive:

> This does not mean that I am a man without anger—I've had my work in museums where I wasn't allowed to see it—but what I pour into my work is the challenge of how beautiful life can be.*

The civil rights struggles of the 1960s encouraged White to move to a more active mode of social protest. A series of

*Elsa Honig Fine, *The Afro-American Artist* (New York: Holt, Rinehart, and Winston, 1973), p. 172.

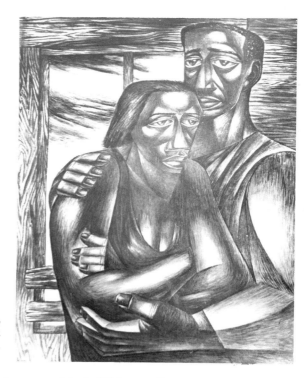

Fig. 6-5. Charles White, "Two Alone," Atlanta University Collection.

charcoal drawings entitled "J'Accuse" and his "Wanted Poster" series are angry, effective works of political propaganda that are technically brilliant. White, who continued to produce outstanding works of social conscience until his death, established himself as a major figure in Afro-American art.

A concurrent and related development of the increasingly militant 1960s civil rights movement was the renaissance of young, socially committed Black artists. Many of these women and men have been active participants in the struggles of their people. They have found that their art is inseparable from their political involvements. Frequently, they view their artworks as instrumental in consciousness raising in the Black community. Many of their paintings, graphic works, and murals have been savagely critical of U.S. racism. And many of these artists have been intentionally unsubtle, producing hardhitting works that demand attention be paid to those racial inequities existing throughout U.S. history.

Faith Ringgold

The works of Faith Ringgold, Reginald Gammon, and David Hammons provide an excellent introduction to contemporary developments in Black art. Born in Harlem in 1934, Ringgold has been actively involved in the social and political affairs of the Black community. Motivated by a concern with U.S. racism, she has used her art to advocate social positions. An exceptional painting of 1967 entitled

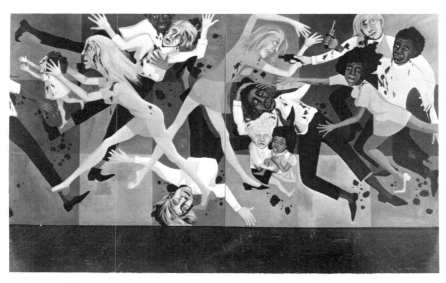

Fig. 6-6. Faith Ringgold, "Die," photo by Malcolm Varm.

"Die" (figure 6-6), depicts the racist madness of the 1960s. Blood and terror dominate the composition; people try desperately to escape from the grotesque pattern of mutual hatred and distrust. The work is not a depiction of Black against white. Indeed, the painting's message is clear: the violence inevitable in a racist society reduces the human potential of all people, regardless of color. Two children, one Black and one white, symbolize the innocence of the victims in an historical pattern of racial turbulence that continues today.

Reginald Gammon probes the past to engender widespread ethnic consciousness among Blacks. The 1969 painting "Scottsboro Boys" (figure 6-7) resurrects an infamous example of racial injustice in the U.S. In 1931, nine young Black men were arrested for an alleged rape in Alabama. The trial was conducted in an atmosphere of mob hysteria, and inevitably, the nine defendants were found guilty. All except the youngest defendant, fourteen years old, were given the death sentence. The case became a national *cause celebre* and various left-wing groups rallied to the support of the condemned young men. After enormous internal strife among various defense committees and lengthy legal appeals, the Scottsboro boys were finally released. While Gammon's painting of the herded, bewildered Scottsboro boys recounts a specific incident, the painting really stands as a more universal symbol of all imprisoned Black men and women.

David Hammons (1943-) has been fundamentally influenced by Charles White. Thoroughly political, Hammons' belief that Blacks must perceive themselves as Blacks first and Americans second is a recurrent theme in his work. A

Reginald Gammon

David Hammons

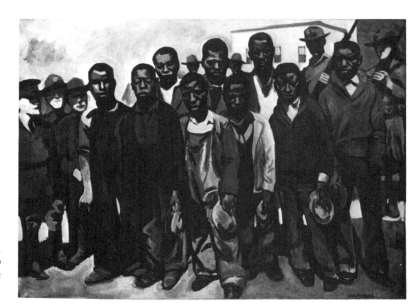

Fig. 6-7. Reginald Gammon, "Scottsboro Boys," courtesy of the artist.

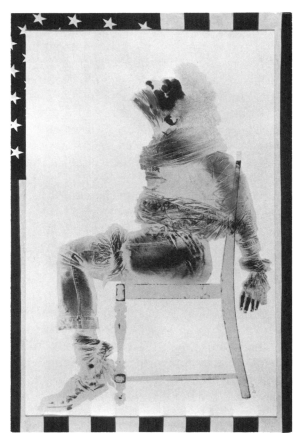

Fig. 6-8. David Hammons, "Injustice Case," Los Angeles County Museum of Art.

1970 "body print," in which the artist pressed his own coated body on illustration board, bitterly comments on racial discrimination in the U.S. criminal justice system. "Injustice Case" (figure 6-8) is modeled on the infamous Chicago 7 trial, during which Black Panther leader Bobby Seale was gagged and bound to his chair. The work serves as an indictment of contemporary judicial institutions, perceived by the artist as rubber-stamp agencies for racial injustice. The most prominent feature of the print is its American flag border, a feature which underpins the connection between generalized racism in society and particular instances of discrimination within legal institutions.

The Jewish Experience

The historical impact of racial discrimination has rarely been felt as deeply as among Jews throughout the world. The unspeakable barbarism of the Nazi genocide is only the most monstrous example of persecution endured by Jews throughout their long period of history and civilization. The traumatic impact of the Holocaust, however, has forged a new commitment to the values and traditions of Jewish identity. The consciousness has found expression in virtually every medium of creative endeavor.

The post-war period has seen an impressive resurgence of Jewish themes in the visual arts. Significantly, many of the important 20th century U.S. artists of social conscience have also treated Jewish subject matter in their work. Ben Shahn, William Gropper, Jack Levine, and Leonard Baskin have forged a Jewish foundation for their ethical concerns in art, fusing a Jewish heritage with a deeply felt obligation toward humanity in general.

The grisly events in Europe during the fascist darkness serves as the immediate historical catalyst for this development. As a result of an official, calculated, and systematic policy, 6,000,000 Jews were murdered, mostly during the period from 1941 through 1945. Under the racial policies of the Third Reich, the Nazi apparatus moved from legal restrictions against Jews in Germany and the occupied countries to a series of extermination camps throughout Europe. The major names are known to virtually everyone: Auschwitz, Buchenwald, and Dachau. These and numerous others carried out the relentless process of annihilation. Known grotesquely as "The Final Solution," the total picture is as incredible as it is horrifying.

The enormity of the Nazi crime, ironically, may make it easier to forget what has so recently happened. One of the major objectives of several American artists has been to prevent these events from being neglected or forgotten. This is important, of course, because an understanding of the past

*Mauricio Lasansky
(1914-)*

at least elevates the probabilities of preventing future atrocities.

The art of Mauricio Lasansky (1914-) provides one of the most troubling reminders of human barbarism in the history of art. Born in Argentina, Lasansky has lived and worked in the U.S. since 1943. His graphic work on the Holocaust is perhaps the definitive treatment of the subject. In a series of works executed between 1961 and 1966, Lasansky produced the highly allegorical "Nazi Drawings" which combine powerful commentary with distinctive artistic style. The powerful cumulative impact can best be felt only after a confrontation with the series as a whole.

For more specific impact, however, individual efforts can be examined. Number 19 in the series (figure 6-9) is a terrifying example. The female victim is shown in an emaciated state, like the millions of corpses, living and dead alike, in Auschwitz. A prominent feature of the work is the presence of the concentration camp tattoo, the ultimate symbol of the dehumanizing brutality of the Nazi machine. The victim is being devoured by vultures, symbolic of the Nazis' morbid procedure of collecting the gold fillings and hair of their victims. The total effect is devastating; the life-size stature of the figures in this and the other works in "The Nazi Drawings" generates a visual experience not easily forgotten. Lasansky's achievement in his art, therefore, compels his viewers to mourn for all victims of barbarism, both past and present.

Ben Shahn too was deeply affected by the tragic events of the German persecution of the Jews. In 1963, he executed a serigraph to commemorate the heroic resistance of the Jews of the Warsaw ghetto. Created by the Nazis in 1940, its population soon grew to half a million people. By 1942, the Germans were removing thousands for deportation to various concentration camps and virtually certain death. By 1943, a vigorous resistance was established, causing the Germans to deploy additional military forces to the Polish capital. The Jewish resistance fighters of the Warsaw ghetto acted with incredible courage in the face of Nazi terror. In "Warsaw," 1943 (figure 6-10), the upraised hands reveal the pain of the Jewish survivors. The Hebrew text tells of the sorrows of the destruction of Warsaw and of the bitterness because no one came to the assistance of the heroic Jewish martyrs, adding verbal force to the social message.

The end of World War II would not, unfortunately, end the pattern of barbarous conduct against Jews throughout the world. Events in the Soviet Union under Stalin and his successors have kept alive the disgraceful pattern of anti-Semitism. The struggles of Jews to create and maintain a national homeland in Israel, moreover, have made latent

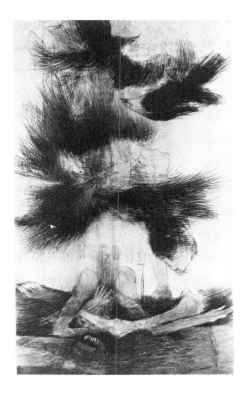

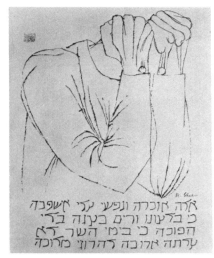

Fig. 6-10. Ben Shahn, "Warsaw," © estate of Ben Shahn.

אלה אזכרה ונפעי עלי אשפכה
כי בלעונו ורים בעונה בר׳
הפוכה כי ב׳מי השר רא׳
עלתה ארובה להרוני מלוכה

Fig. 6-9. Mauricio Lazansky, "The Nazi Drawings #19," courtesy of Richard S. Levitt Foundation.

prejudices against Jews a matter of more open expression in recent years.

Abraham Rattner, not normally a social painter, was moved to create a series of 38 paintings to express his moral outrage at an event in Baghdad, Iraq in 1969. On January 26, the Iraqi government condemned 16 persons, including 9 Jews, to death for allegedly spying for Israel. The executions were conducted in the public square, to the hysterical cheering of a delirious crowd. The hangings were viewed with revulsion throughout much of the world, including many parts of the Arab world. The artist's horror was directed at the rejoicing crowds and their irrational frenzy and excitement. This fanaticism reminded him of his parents' tales of the brutal Russian pogroms. It reminded him, too, of the historical role of Jews as scapegoats for the frustrations and deprivations of others.

Once again, though a view of the series as a whole is necessary to gauge its artistic and moral impact, individual efforts in "The Gallows of Baghdad" provide a glimpse into the topical and universal problems that Rattner treats with such dramatic power. "Delirium in Baghdad" (figure 6-11) is an excellent example. The artist depicts the carnival-like atmosphere that prevailed during the public executions. The laughing, mocking expressions of the crowd symbolize the

Abraham Rattner

153

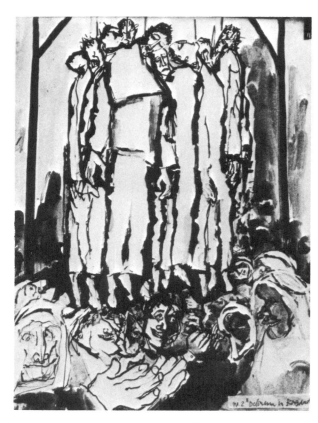

Fig. 6-11. Abraham Rattner, "Delirium in Baghdad," Tel Aviv Museum, Israel.

cruel and vicious propensities that linger all too often beneath the civilized facades of human beings. A bitter view of the specific events in Iraq, the painting also comments on human motivations in general.

Happily, a significant feature of contemporary Jewish art involves a sensitive portrayal of Jewish life and experience. One of the finest artists to treat the exuberance of Jewish culture and tradition was William Gropper, one of the original Social Realists, and himself a product of the suffering and joy that has marked so much of Jewish history.

His sympathetic portrayals of Jewish bakers, tailors, cigar makers and others—Jewish workers in the early decades of the 20th century—stand as hallmarks of ethnically conscious art in the U.S. Equally significant is his treatment of the joyous vigor of Judaism, including "Wedding" (figure 6-12), painted in 1965. Gropper focuses on Hassidic celebration by highlighting the gaiety and fervor of a Jewish wedding. An authentic affirmation of the Jewish temper and spirit, the painting is also significant for its broader historical implications: in the face of persecution and oppression, the Jewish tradition has managed to remain intact by drawing upon a well-spring of strength predicated on religious faith, a

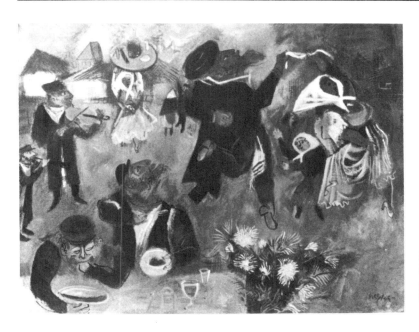

Fig. 6-12. William
Gropper, "Wedding,"
courtesy of Harry
Belafonte Collection.

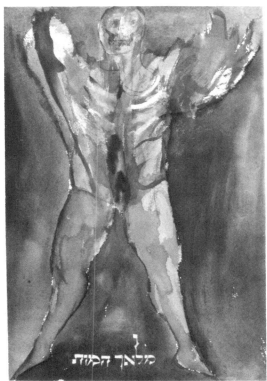

Fig. 6-13. Leonard Baskin, "In
Every Generation, in Every Age,
Some Rise up to Plot Our
Annihilation," courtesy of
Central Conference of American
Rabbis.

strong sense of community, and above all a system of law and ethics.

A more somber view of the same spirit was expressed in a recent watercolor by Leonard Baskin (figure 6-13). Acutely aware of the patterns of persecution, Baskin issued a powerful pictorial warning in a work done as part of a Passover Haggadah. The caption of the illustration echoes the reminder that is part of the Passover ritual: "In every generation, in every age, some rise up to plot our annihilation." Harsh and blunt, the work imposes a demand for eternal Jewish vigilance against the insidious specter of anti-Semitism.

The message, however, is addressed with equal force to those who would add to the infamous history of religious and cultural oppression. The strong figure that dominates the composition serves notice to the world that the days of Jewish passivity are long past. Neither chauvinistic nor ethnocentric, the drawing is a vigorous affirmation of the right to self-determination and self-preservation, a principle equally applicable to any ethnic group seeking to define its own identity. The role of ethnically conscious art, hopefully, is to facilitate that principle.

AFTERWORD

The dominant institutions of cultural life in the United States ensure the marginality of socially conscious art. For artists generally, recognition and economic survival depend on exhibitions in established galleries and museums and attention in orthodox periodicals and newspapers. The prevalent scheme of marketing, distributing, and reviewing art is often competitive, arbitrary, and discriminatory. This system guarantees that economic and status considerations will prevail over aesthetic and moral concerns.

For socially engaged artists the present arrangements are especially difficult. The content of their art is antithetical to marketplace forces. Their works criticize the very institutions that perpetuate the pattern of politcal and cultural domination. Furthermore, there are few alternatives to the well established procedures for exhibiting and marketing art. Progressive communities have yet to provide their artists with options that permit significant departures from the present system. And while there are many left-oriented publishing enterprises and journals, few devote substantial attention to cultural affairs. Socially conscious artists ironically have difficulty in obtaining recognition even within communities sympathetic to their objectives. In the 80s, there are no counterparts to *The Masses* and *The New Masses*, which provided an ample outlet for critical and radical artists to disseminate their creative work. Contemporary political and social artists must survive with far more limited resources.

Despite these severe constraints, there is reason to expect a resurgence of this tradition in coming years. The events and political struggles of the 80s are likely to generate an impressive body of critical visual art in the United States. In times of political reaction, progressive forces are stimulated to organize more vigorously. Recently, there has been a proliferation of social and political movements organized around both local concerns and national and international events. The Reagan presidency has been instrumental in consolidating widespread oppositional activity. Domestically, protests have centered around the harsh impact of budget cuts, the calculated assault on minorities and the poor, the cynical neglect of the natural environment, the cavalier disregard for occupational health and safety, and the conti-

nuing danger of nuclear power. Internationally, increasing numbers of people have mobilized against the threat of nuclear war and U.S. interference in Central America and other Third World regions. All of these activities encourage artistic involvement from men and women who seek to illuminate these issues and to help to solidify the broader political movements of which they are integral parts. Their efforts will extend the tradition of socially conscious art dramatically during the next decade.

These artists will not be seduced by the volatile fashions of the art world. They are motivated by a passionate desire to integrate their work as artists with their broader concerns for social justice. Undiscouraged by those who disparage their efforts, they remain faithful to a more authentic standard of creative success. Their paintings, murals, photographs, posters, prints and artistic forms still to be developed will leave an enduring heritage for humanity generally as it moves toward the awesome challenges of the 21st century.

BIBLIOGRAPHY

GENERAL

American Painting 1910-1970. New York: Time-Life Books, 1970.

Art and Confrontation: The Arts in an Age of Change. Greenwich, Conn: New York Graphic Society, 1968.

Averill, Peg (ed.) *80 Years of Political Art in the U.S.* New York: War Resisters League, 1980.

Baxendall, Lee. *Marxism and Aesthetics: An Annotated Bibliography*. New York: Humanities Press, 1969.

Berger, John. *Ways of Seeing.* London: British Broadcasting Corporation and Penguin, 1973.

Brown, Milton. *American Painting from the Armory Show to the Depression.* Princeton, N.J.: Princeton University Press, 1955.

Canady, John. *Culture Gulch.* New York: Farrar, Straus and Giroux, 1969.

--------. *Embattled Critic.* New York: Farrar, Straus and Giroux. 1962.

Chipp, Herschel B. *Theories of Modern Art.* Berkeley: University of California Press, 1968.

Egbert, Donald D. *Social Radicalism and the Arts.* New York: Alfred A. Knopf, 1970.

--------. *Socialism and American Art.* Princeton, N.J.: Princeton University Press, 1962.

The Eye of the Law (exhibition catalogue). University, Miss.: The University of Mississippi, 1978.

Feaver, William. *Masters of Caricature.* New York: Alfred A. Knopf, 1981.

Foner, Moe (ed.). *Images of Labor.* New York: The Pilgrim Press, 1981.

Getlein, Frank, and Dorothy Getlein. *The Bite of the Print.* New York: Potter, 1963.

Hauser, Arnold. *The Social History of Art.* Vols 1-4. New York: Vintage Books, 1957-58.

Heller, Steven (ed.). *Man Bites Man.* New York: A and W Publishers, 1981.

Horwitz, Elinor L. *Contemporary American Folk Artists.* Philadelphia: J.B. Lippincott, 1975.

Hunter, Sam and John Jacobus. *American Art of the 20th Century.* New York: Harry N. Abrams, 1973.

Lang, Berel, and Forest Williams. *Marxism and Art: Writings in Aesthetics and Criticism.* New York: McKay, 1972.

Larkin, Oliver W. *Art and Life in America.* (rev. ed.). New York: Holt, Rinehart and Winston, 1964.

Mathey, Francois. *American Realism.* New York: Rizzoli International Publications, 1978.

Meltzer, Milton and Bernard Cole. *The Eye of Conscience.* Chicago: Follett, 1974.

Miller, Dorothy C. and Alfred H. Barr (eds.). *American Realists and Magic Realists.* New York: Museum of Modern Art, 1943.

Mondale, Joan Adams. *Politics in Art.* Minneapolis: Lerner Publications Co., 1972.

Newhall, Beaumont. *History of Photography from 1930 to the Present.* New York: Museum of Modern Art, 1964.

Rose, Barbara. *American Art Since 1900.* New York: Praeger, 1967.

Schwartz, Barry. *The New Humanism.* New York: Praeger, 1974.

Selz, Peter. *Art in Our Times: A Pictorial History.* New York: Harry N. Abrams, 1981.

Shahn, Ben. *The Shape of Content.* Cambridge, Mass.: Harvard University Press, 1957.

Shikes, Ralph. *The Indignant Eye.* Boston: Beacon, 1969.

Taylor, Joshua. *America as Art.* Washington, D.C.: Smithsonian Institution Press, 1976.

Von Blum, Paul. *The Art of Social Conscience.* New York: Universe Books, 1976.

The Working American (exhibition catalogue). New York: District 1199, National Union of Hospital and Health Care Employees and the Smithsonian Institution, 1979.

CHAPTER 1:
18TH AND 19TH CENTURY ORIGINS

Keller, Morton. *The Art and Politics of Thomas Nast.* New York: Oxford University Press, 1968.

Lipman, Jean and Tom Armstrong (eds.). *American Folk Painters of Three Centuries.* New York: Hudson Hills Press, Inc., in Association with the Whitney Museum of American Art, 1980.

Mather, Eleanore Price. *Edward Hicks.* Princeton, N.J.: Pyne Press, 1973.

Paine, Albert B. *Thomas Nast: His Period and His Pictures.* Princeton, N.J.: Pyne Press, 1974.

Riis, Jacob. *How the Other Half Lives.* New York: Dover, 1971.

St. Hill, Thomas Nast. *Thomas Nast: Cartoons and Illustrations.* New York: Dover, 1974.

CHAPTER 2:
EARLY 20TH CENTURY SOCIAL AND POLITICAL ART

Braider, Donald. *George Bellows and the Ashcan School of Painting.* Garden City, N.J.: Doubleday and Co., 1971.

Brooks, Van Wyck. *John Sloan, A Painter's Life*. New York: E.P. Dutton, 1955.

Fitzgerald, Richard. *Art and Politics*. Westport, Conn: Greenwood Press, 1973.

Glackens, Ira. *William Glackens and the Ashcan Group*. New York: Grosset and Dunlap, 1957.

John Sloan 1871-1951. Boston: Boston Book and Art, 1971.

John Sloan: Paintings, Prints, Drawings (exhibition catalogue). Hanover, N.H.: Hood Museum of Art, Dartmouth College, 1981.

Perlman, Bernard P. *The Immortal Eight; American Painting from Eakins to the Armory Show*. New York: Exposition Press, 1962.

Young, Mahonri S. *The Paintings of George Bellows*. New York: Watson-Guptill Publications, 1973.

CHAPTER 3:
WORLD WAR I TO WORLD WAR II: SOCIAL
REALISM AND THE FLOWERING OF A HUMANIST
ARTISTIC TRADITION

Agee, James and Walker Evans. *Let Us Now Praise Famous Men*. New York: Ballantine Books, 1976.

Baigell, Matthew. *The American Scene*. New York: Praeger, 1974.

--------. *Thomas Hart Benton*. New York: Harry N. Abrams, 1974.

Bauer, John. *Philip Evergood*. New York: Praeger, 1960.

Ben Shahn: Voices and Visions (exhibition catalogue). Santa Fe, New Mexico: Santa Fe East, 1981.

Bourke-White, Margaret. *Portrait of Myself*. New York: Simon and Schuster, 1963.

Bush, Martin H. *Ben Shahn: The Passion of Sacco and Vanzetti*. Syracuse University Press, 1968.

Callahan, Sean (ed.). *Photographs of Margaret Bourke-White*. Greenwich, Conn.: New York Graphic Society, 1972.

Cole, Sylvan (ed.), *Raphael Soyer: Fifty Years of Printmaking* (rev. ed.). New York: Da Capo Press, 1978.

Conrat, Maisie and Richard Conrat. *Executive Order 9066*. Cambridge, Mass.: MIT Press, 1972.

Croydon, Michael. *Ivan Albright*. New York: Abbeville Press, 1978.

Dennis, James. *Grant Wood*. New York: Viking, 1975.

Eaton, Allen H. *Beauty Behind Barbed Wire*. New York: Harper, 1952.

Elliot, George (ed.). *Dorothea Lange*. New York: Museum of Modern Art, 1966.

Evans, Walker. *Walker Evans: Photographer for the Farm Security Administration, 1935-1938*. New York: Da Capo—Plenum, 1969.

Freundlich, August L. *William Gropper: Retrospective*. Los Angeles: Ward-Ritchie Press, 1968.

Garwood, Darrell. *Grant Wood*. New York: W.W. Norton and Co., 1944.

Goodrich, Lloyd. *Edward Hopper*. New York: Harry N. Abrams, 1971.

--------. *Raphael Soyer*. New York: Harry N. Abrams, 1972.

--------. *Reginald Marsh*. New York: Harry N. Abrams, 1972.

Graphic Works of the American 30's. New York: Da Capo Press, 1977.

Gutman, Judith M. *Lewis W. Hine and the American Social Conscience*. New York: Walker, 1967.

Heller, Nancy and Julia Williams. *The Regionalists*. New York: Watson-Guptill, 1976.

Hudson, Richard and Ben Shahn. *Kuboyama and the Saga of the Lucky Dragon*. New York: Yoseloff, 1965.

Hurley, F. Jack. *Portrait of a Decade; Roy Stryker and the Development of Documentary Photography in the Thirties*. Baton Rouge: Louisiana State University, 1972.

Johnson, Una E. *Paul Cadmus: Prints and Drawings*. Brooklyn: Brooklyn Museum, 1968.

Kent, Rockwell. *It's Me, O Lord: The Autobiography of Rockwell Kent*. New York: Da Capo, 1977.

Krauss, Rosalind E. *Terminal Iron Works: The Sculpture of David Smith*. Cambridge, Mass.: The MIT Press, 1971.

Lange, Dorothea and Paul S. Taylor. *An American Exodus*. New York: Reynal and Hitchcock, 1939.

Larkin, Oliver W. *Twenty Years of Evergood*. New York: Simon and Schuster, 1946.

Levin, Gail. *Edward Hopper*. New York: W.W. Norton & Co., 1980.

--------. *Edward Hopper: The Complete Prints*. New York: W.W. Norton & Co., 1979.

Lewis Hine. New York: Grossman, 1974.

McKinzie, Richard D. *The New Deal for Artists*. Princeton, N.J.: Princeton University Press, 1973.

Meltzer, Milton. *Dorothea Lange: A Photographer's Life*. New York: Farrar, Straus and Giroux, 1978.

Mine Okubo: An American Experience (exhibition catalogue). Oakland, Calif.: Oakland Museum, 1972.

Morse, John D. (ed.). *Ben Shahn*. New York: Praeger, 1972.

O'Connor, Francis V. (ed.). *Art for the Millions*. Greenwich, Conn.: New York Graphic Society, 1973.

--------. *Federal Suppport for the Visual Arts: the New Deal and Now*. Greenwich, Conn.: New York Graphic Society, 1969.

---------. (ed.). *The New Deal Art Projects: An Anthology of Memoirs*. Washington, D.C.: Smithsonian Institution Press, 1972.

Okubo, Mine. *Citizen 13660*. New York: Columbia University Press, 1946.

Park, Marlene and Gerald E. Markowitz. *New Deal for Art*. Hamilton, N.Y.: The Gallery Association of New York State, 1977.

Patri, Giacomo. *White Collar* (reprint). Millbrea, Calif.: Celestial Arts Publishing Co., 1976.

Prescott, Kenneth W. *The Complete Graphic Works of Ben Shahn*. New York: Quadrangle, 1973.

Sasowsky, Norman. *The Prints of Reginald Marsh*. New York: Clarkson N. Potter, Inc., 1976.

7 American Women: The Depression Decade. (exhibition catalogue). New York: A.I.R. Gallery, 1976.

Shahn, Bernarda Bryson. *Ben Shahn*. New York: Harry N. Abrams, 1972.

Shapiro, David (ed.). *Social Realism: Art as Weapon*. New York: Ungar, 1973.

Soby, James Thrall. *Ben Shahn: His Graphic Art*. New York: Braziller, 1957.

--------. *Ben Shahn: Paintings*. New York: Braziller, 1963.

Soyer, Raphael. *Self-Revealment: A Memoir*. New York: Maecenas Press/Random House, 1967.

Steichen, Edward (ed.). *The Bitter Years, 1935-1941*. New York: Museum of Modern Art, 1962.

Stryker, Roy Emerson and Nancy Wood. *In this Proud Land: America 1935-1943 As Seen in the FSA Photographs*. Greenwich, Conn.: New York Graphic Society, 1973.

Traxel, David. *An American Saga: The Life and Times of Rockwell Kent*. New York: Harper and Row, 1980.

Walker Evans. New York: The Museum of Modern Art, 1971.

WPA/FAP Graphics (exhibition catalogue). Washington, D.C.: Smithsonian Institution Press, 1976.

CHAPTER 4:
THE HEIRS OF SOCIAL REALISM

Baskin, Leonard. *Baskin: Sculpture, Drawings and Prints*. New York: Braziller, 1970.

--------. *The Graphic Work 1950-1970*. New York: Far Gallery, 1970.

Frasconi, Antonio. *Frasconi Against the Grain*. New York: Collier Books, 1974.

Garber, Thomas. *George Tooker* (exhibition catalogue). San Francisco: The Fine Arts Museums of San Francisco, 1974.

Getlein, Frank. *Jack Levine*. New York: Harry N. Abrams, 1966.

Jaffe, Irma B. *The Sculpture of Leonard Baskin*. New York: Viking, 1980.

Lyon, Danny. *Pictures from the New World*. New York: Aperture, 1981.

Peter Saul (exhibition catalogue). Dekalb, Ill.: Northern Illinois University, 1980.

Scholder/Indians. Flagstaff, Arizona: Northland Press, 1972.

Taylor, Geoffrey. *The Absurd World of Charles Bragg*. New York: Harry N. Abrams, 1980.

Two American Painters: Fritz Scholder and T.C. Cannon (exhibition catalogue). Washington, D.C.: Smithsonian Institution Press, 1972.

Von Blum, Paul. *Audrey Preissler: An American Humanist Artist of Today*. Montclair, N.J.: Allanheld and Schram, 1981.

Watson, Patrick. *Fasanella's City*. New York: Ballantine Books, 1973.

CHAPTER 5:
THE 60'S AND 70'S: A PROLIFERATION OF FORMS

Blaisdell, Thomas and Peter Selz. *The American Presidency in Political Cartoons: 1776-1976*. Berkeley: University Art Museum, 1976.

Block, Herbert. *The Herblock Book*. Boston: Beacon Press, 1952.

--------. *Herblock's State of the Union*. New York: Grossman Publishers, Viking Press, 1974.

Bush, Martin H. *Duane Hanson*. Wichita, Kansas: Wichita State University, 1976.

Clark, Yoko and Chizo Hama. *California Murals*. Berkeley: Lancaster-Miller Publishers, 1979.

Cobb, Ron. *The Cobb Book*. Sydney: Wild and Woolley, 1975.

--------. *My Fellow Americans*. Los Angeles: Sawyer, 1970.

--------. *Raw Sewage*. Los Angeles: Sawyer, 1970.

Cockcroft, Eva, John Weber, and James Cockcroft. *Toward a People's Art*. New York: E.P. Dutton and Co., 1977.

Environmental Communications. *Big Art*. Philadelphia: Running Press, 1977.

Feiffer, Jules. *Feiffer on Nixon*. New York: Random House, 1972.

Feiffer on Civil Rights. New York: Anti-Defamation League of B'nai B'rith, 1966.

Garcia, Rupert. *Raza Murals and Muralists*. San Francisco: Galeria de la Raza, 1974.

The Image of America in Caricature and Cartoon (exhibition catalogue). Fort Worth, Texas: Amon Carter Museum of Western Art, 1975.

Kienholz, Edward, *11 & 11 Tableaux*. Stockholm: Moderna Museet, 1970.

Kunzle, David. *American Posters of Protest, 1966-1970 (exhibition catalogue)*. New York: New School Art Center, 1971.

Levine, David. *No Known Survivors*. Boston: Gambit, 1970.

Pocock, Philip. *The Obvious Illusion: Murals from the Lower East Side*. New York: Braziller, 1980.

Rennert, Jack (ed.). *The Poster Art of Tomi Ungerer*. New York: Dover Publications, 1973.

Rickards, Maurice. *Posters of Protest and Revolution*. New York: Walker, 1970.

Rogovin, Mark, Marie Burton and Holly Highfill. *Mural Manual*. Boston: Beacon Press, 1975.

Saures, Jean Claude. *Art of the Times*. New York: Universe Books, 1973.

Seitz, William. *Segal*. New York: Henry N. Abrams, 1972.

Steadman, Ralph. *America*. New York: Random House, 1974.

Van der Marck, Jan. *George Segal*. New York: Harry N. Abrams, 1975.

Watergate Without Words. San Francisco: Straight Arrow Publishers, 1975.

Yanker, Gary. *Prop Art*. New York: Darien House, Inc., 1972.

CHAPTER 6:
A CASE STUDY IN THE ART OF SOCIAL CONSCIENCE:
THE AFRO-AMERICAN AND JEWISH EXPERIENCE

Abraham Rattner: The Gallows of Baghdad (exhibition catalogue). New York: New School Art Center, 1970.

Afro-American Artists. Boston: Boston Public Library, 1973.

Atkinson, J. Edward (ed.). *Black Dimensions in Contemporary American Art*. New York: New American Library, 1971.

Bearden, Romare and Harry Henderson. *6 Black Masters of American Art*. Garden City, N.Y.: Doubleday, 1972.

Bronstein, Herbert (ed.). *A Passover Haggadah: Drawings by Leonard Baskin*. New York: Central Conference of American Rabbis, 1974.

Brown, Milton. *Jacob Lawrence* (exhibition catalogue). New York: Whitney Museum of American Art, 1974.

Fine, Elsa Honig. *The Afro-American Artist*. New York: Holt, Rinehart and Winston, 1973.

Horowitz, Benjamin. *Images of Dignity: The Drawings of Charles White*. Los Angeles: Ward-Ritchie Press, 1967.

Lewis, Samella and Ruth G. Waddy. *Black Artists on Art*. (2 volumes). Los Angeles: Contemporary Crafts Publishers, 1969.

Locke, Alain. *The Negro In Art*. New York: Hacker Art Books, 1968.

Rodman, Selden. *Horace Pippin: A Negro Painter in America*. New York: Quadrangle Press, 1947.

INDEX